Artur Landt/Joe Farace
Canon EOS Elan 7/7E
Canon EOS 33/30

D1622184

Magic Lantern Guides

Canon
EOS ELAN 7/7E
EOS 33/30

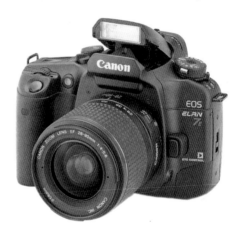

Artur Landt/Joe Farace

**Magic Lantern Guide to
Canon EOS Elan 7/7E
Canon EOS 33/30**

Published by

Silver Pixel Press®
A Tiffen® Company
21 Jet View Drive
Rochester, NY 14624 USA
www.silverpixelpress.com

ISBN 1-883403-88-X

From the German edition by Artur Landt
Edited by Joe Farace
Translated by Hayley Ohlig

Printed in Germany by Kösel, Kempten
www.Koeselbuch.de

©2000 Laterna magica, Verlag Georg D.W. Callwey GmbH & Co.,
Munich, Germany

©2001 English Language Edition, Silver Pixel Press

Library of Congress Cataloging-in-Publication Data
Landt, Artur, 1958–
 Canon EOS Elan 7/7E, EOS 33/30 / Artur Landt, Joe Farace.
 p. cm. — (Magic lantern guides)
 ISBN 1883403-88-X
 1. Canon camera—Handbooks, manuals, etc. I. Farace, Joe. II. Title.
 III. Series
 TR263.C3 L37 2001
 771.3'2—dc21 2001018405

Contents

Introduction

The EOS Elan 7/7E

The Canon EOS Elan 7 and 7E are designed for aspiring amateur as well as professional photographers who want an autofocus 35mm SLR that will support and enhance their photographic and creative skills. The functions of the two camera models are identical except for the Eye Controlled Focus feature found in the EOS Elan 7E. The 7E is also available in a quartz date (QD) version, which has a data back that prints the time and date on the film frame. In the United States and Canada, the cameras are called the 7 and 7E. In Europe and the rest of the world, the 7 is known as the EOS 33 and the 7E as the EOS 30 (the quartz date version is the EOS 30 QD).

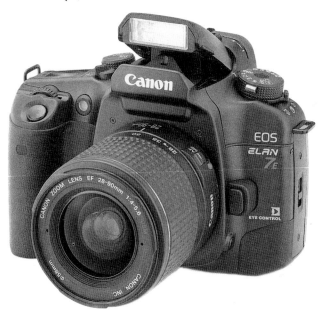

Canon EOS Elan 7E camera

The Elan 7/7E models are built from aluminum alloy and poly-carbonate, and are available in black; their well-placed controls are ergonomically designed. In addition, the cameras boast enough high-tech components to satisfy the most fervent technophile, yet retain a high level of user friendliness.

Highlights of the Elan 7/7E cameras include:

❏ An autofocus system, based on the one in the EOS 1V and EOS 3, that uses a proprietary CMOS (Complementary Metal Oxide Semiconductor) sensor chip. Seven autofocus sensors produce sharp focus regardless of subject position in the viewfinder.

❏ Multi-zone metering, with three metering modes, that is linked to the camera's seven AF focusing points.

❏ Eye Controlled Focus (7E), the fastest eye-controlled focusing system on the market.

❏ A Command Dial that provides access to 11 different shooting modes; along with the 13 Custom Functions, 34 different camera settings are possible.

❏ A Whisper Drive film transport mechanism that makes the Elan 7/7E the two quietest cameras in the EOS line up—even with the impressive maximum speed of four frames per second.

❏ Built-in eyepiece diopter correction, depth-of-field preview button, mirror lockup, multiple exposure function, and flash exposure correction.

❏ Exposure options include Shutter-speed Priority, Aperture-Priority, and Manual Exposure modes, along with auto exposure bracketing in half-step increments up to plus or minus 2 stops. A flexible Program mode allows the selected shutter speed–aperture combination to be shifted while maintaining the proper exposure value. A Depth-of-Field (DEP) mode ensures that two points selected using the AF system are in focus in the image. In addition, the Elan 7/7E offer subject modes for portraits, landscapes, close-ups, sports, and night shots, making it possible to use the Elan 7/7E like 35mm compact cameras.

❏ An optional BP-300 battery pack, with vertical-format shutter release.

Let the Photography Begin!

This brief overview highlights the technical and creative possibilities of your Elan 7/7E. With either camera, a whole new world of photographic enjoyment awaits you.

Elan 7/7E Camera Controls

Part of the way any camera performs depends on how it feels—and a camera is only as good as it feels in your hand. Canon's designers have made this requirement an essential component of every EOS camera they've produced, but with the Elan 7/7E the ergonomics may be the best yet.

Controls follow the curves of the camera and are partially recessed into the housing, adding to an overall positive visual impression. The controls are easily operated, clearly marked, and located where you might expect, especially for owners of other Canon EOS cameras.

Note: All orientations mentioned in the book are based on holding the camera in a horizontal position—as if you were actually going to use it—with the viewfinder facing your body.

Canon EOS Elan 7/7E—Top

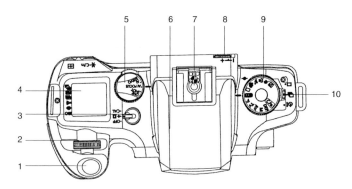

1. Shutter button
2. Main Dial
3. Eye Control switch
4. LCD panel
5. AF mode dial
6. Built-in flash (retracted)/ AF-assist light
7. X-sync contact
8. Dioptric adjustment knob
9. Command Dial
10. Film advance mode lever

Canon EOS Elan 7/7E—Front

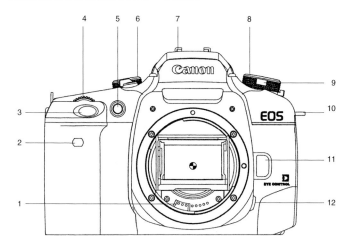

1. Lens mount contacts
2. Wireless remote control sensor
3. Shutter button
4. Main Dial
5. Red-eye reduction lamp
 Self-timer lamp
 Wireless remote control operation lamp
6. AF mode dial
7. Hot shoe
8. Command Dial
9. Command Dial lock release button
10. Strap eyelet
11. Lens release button
12. Depth-of-field preview button

The Command Dial is located on the top left. This dial is used to select all exposure programs and serves as the camera's main on-off switch. To move it from the OFF position and into a subject mode (which turns the camera on), press the Command Dial release button and turn in either direction.

On the upper right side, you'll find other important controls. Below the shutter button is the Main Dial, used to shift program exposure or manually select shutter speed or aperture.

The switches and dials for selecting AF mode and eye control are also located on the top right, next to the LCD panel (the eye control switch in the 7E is also on the top right). On the camera's back are thumb keys found in the middle of the Quick Control

Canon EOS Elan 7/7E—Back

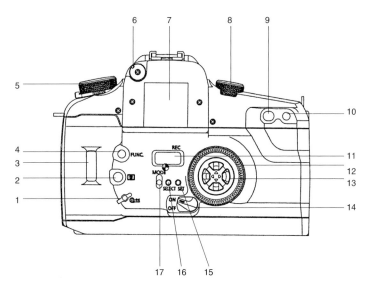

1. Midroll rewind button
2. Metering mode button
3. Film window
4. Function button
5. Command Dial
6. Dioptric adjustment knob
7. Viewfinder eyepiece
8. AF mode dial
9. AE lock/FE lock/Custom
 Function setting button

10. Focusing point selector
11. Date display panel *
12. Quick Control Dial
13. Focusing point selection key
14. Quick Control Dial switch
15. SET button *
16. SELECT button *
17. MODE button *

* QD model only

Dial, used to select the AF focusing point. Custom Function 12 can be used to program the focusing point selector so the central AF field is activated when the selector is pressed.

The LCD Panel

The LCD (liquid crystal display) panel on the top right of the camera acts as the control and information center for the Elan 7/7E. It displays all of the information about the camera's settings, as well

Canon EOS Elan 7/7E—LCD Panel

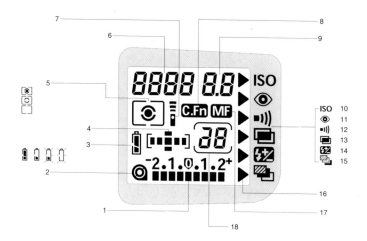

1. Exposure Level
 Red-eye reduction lamp on
 Film rewind in progress
2. Film/status
3. Battery level (4 levels)
4. Focusing point selection
5. Metering mode
 Evaluative metering
 Partial metering
 Centerweighted averaging
 metering
6. Shutter speed
 Depth-of-field AE
 ISO film speed
 Custom Function number
 Calibration Number
7. Remote control icon
8. Custom Function icon
9. Aperture
 Red-eye reduction setting

 Beeper setting
 AEB amount
 DEP points
 Custom Function setting
 Calibration
10. ISO film speed icon
11. Red-eye reduction icon
12. Beeper icon
13. Multiple-exposure icon
14. Flash exposure compensation
 icon
15. AEB icon
16. Function setting arrow
17. Manual Focus icon
18. Frame counter
 Multiple-exposure setting
 Self-timer operation
 Wireless remote control
 operation

as battery capacity and Custom Function status, and serves as a digital frame counter. The diagram above shows all possible displays, but the LCD panel would not appear like this under actual

15

conditions. Only the currently active functions are displayed, making the panel easier to read.

The LCD panel uses liquid crystals to display information. At temperatures of 100°F (60°C), which can easily be reached inside a car, the LCD panel turns black. At temperatures around freezing, the display may react slowly. The liquid crystals recover from temperature-related failures as soon as a temperature around 68°F (20°C) is reached. Over time, LCD displays can fade and become hard to read. If this happens, have the panel replaced by Canon Customer Service. LCD panels can also crack from rough or neglectful treatment, so handle them gently.

The Viewfinder

Careful photographers always like to know exposure-related data and camera settings without having to remove the camera from their eye. On the viewfinder of the 7/7E, you'll find seven rectangular markings that indicate the seven AF focusing points. A central, slightly matte circle—about 10% of the viewfinder screen—serves as a reference mark for the partial-metering zone.

Important image information is displayed on a bar below the viewfinder image. The illustration on the right shows all the possible displays available. When you're actually shooting, only those elements that are currently active in the camera are displayed, making the viewfinder display easier to read.

Eyepiece Diopter Correction
The control dial for the built-in eyepiece diopter correction is located to the left of the viewfinder eyepiece, under the eyecup.

The control dial for the built-in diopters is to the left of the eyepiece.

Canon EOS Elan 7/7E—Viewfinder

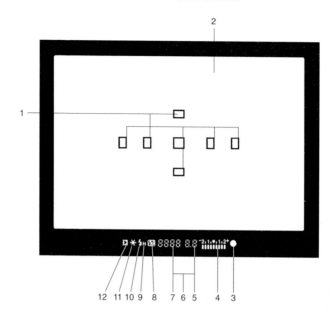

1. Focusing points
2. New Lasermatte focusing screen
3. In-focus indicator
4. Exposure level
 Exposure compensation amount
 AEB range
 Red-eye reduction lamp-on indicator
5. Aperture display
6. FEL display
 CAL display
 DEP point display
7. Shutter speed
8. Flash exposure compensation indicator
9. High-speed sync (FP flash) indicator
10. Flash-ready indicator
 Insufficient flash warning (during FE lock)
11. AE lock indicator
 FE lock indicator
12. Eye Control icon

This adjustment allows eyeglass wearers to remove their glasses and still see a sharp viewfinder image. The eyecup is easily removed by gentle pulling. If there is a lens on the camera, remove it and look through the viewfinder at an evenly illuminated surface, such as the sky or a blank wall.

The eyepiece is calibrated for values between –2.5 and + 0.5 diopter (dpt). When you can see the rectangular markings corresponding to the seven AF focusing points in the viewfinder clearly, the setting is correct. If none of the corrections is strong enough, additional ED correction lenses are available as accessories that cover a range from –4 to +3 dpt. These diopters are mounted into the eyepiece. When combined with the built-in diopters, the control range extends from –6.5 to + 3.5 dpt.

Adding Data with the Elan 7E QD

The only difference between the Elan 7E and the Elan 7E QD is the data back, which allows you to add the date and time to the frame. In horizontal format, the data (in year/month/day, day/hour/minute, month/day/year, or day/month/year sequence) appears in the lower right-hand corner of the frame.

Three buttons on the camera's back are marked MODE, SELECT, and SET. The MODE button is used to select the order of the data, the SELECT button to choose the data element to be entered (it blinks), and the SET button to enter the correct data. The entry is confirmed by pressing the SELECT button until none of the fields is blinking. Once data is entered correctly, use the MODE button to activate the desired combination. If you don't want any data to be added to the frame, you must make sure that "— — —" appears on the back's LCD panel. If any numbers appear, they will be imprinted—no exceptions. This information can be hard to read on a red or light-colored background, but is legible on the finished print or slide.

While this feature can be used to remind you of the date of a certain event, it can also ruin a picture. In vertical shots with the camera grip up, data appears in the upper right-hand corner, often intruding on the effect of the rest of the image. Adding data to a frame is more practical for scientific, business, or research purposes. For more general photographic uses, a better approach is to sacrifice the first shot on the roll to establish and record the date. Test shots can also be identified this way, but data in the frame is more often than not distracting for creative photography.

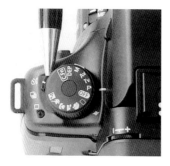

To turn the self-timer on, turn the film advance mode lever to the position identified by the self-timer icon.

The Self-timer

The self-timer can be used in any mode and allows the photographer to appear in the photograph or make vibration-free shots. To turn the self-timer on, move the Film Advance mode lever to the position with the clock-like icon. The remote control icon (it looks like a squiggly line) will appear on the LCD panel data monitor. Countdown is initiated by pressing the shutter release all the way. In AF mode, this only happens after the image is in focus.

The self-timer has a 10-second delay. During that time, the red-eye reduction light flashes to indicate the countdown's progress. It flashes during the first eight seconds, then glows steadily for the last two. If audio signaling is activated, the countdown is accompanied by a beeping sound. In the first eight seconds, the beeper sounds as the light blinks, but when the light stays on during the last two seconds the beeping increases. The countdown can be canceled by turning the Command Dial selector or film advance lever to another position. To turn the function off completely, set the film advance lever on single or continuous mode.

Aside from allowing the photographer to appear in the shot, the self-timer is important with slow shutter speed or telephoto lens shots of stationary subjects. When making these kind of images, the danger of camera shake is high. For self-timer shots, use a sturdy tripod. If there isn't a tripod handy, improvise by placing the camera on a table, windowsill, or against a wall. Use of a tripod and self-timer is also recommended in close-up (macro) photography, where long lens extension increases both exposure times and the risk of camera shake. In these situations,

if you're not looking through the eyepiece during an exposure, you should replace the eyecup with the eyepiece cover attached to the camera strap to eliminate light from entering the system and producing an incorrect exposure metering.

The self-timer can be used in all modes. It works with the camera's built-in or any EOS-compatible accessory flash, and all functions can be used.

The Audible Indicator

The audible indicator (beeper) confirms focus and the progress of the countdown in the self-timer function. Having audio feedback is good no matter how experienced you may be. The beeper can be turned on or off in any program by pressing the function (*) button until the arrow lines up with the audio icon and using the Main Dial to select 1 for on and 0 for off.

Testing Your Camera

Without loading film into the camera, spend some time experimenting with all the camera functions. Begin hands-on learning about your camera by activating and deactivating all the camera functions shown in the diagrams on these pages.

Getting Ready to Use the Elan 7/7E

Getting Started

Now that you've become familiar with the parts of the Elan 7/7E, the next step is to prepare for actual picture taking. In this chapter, you will learn about getting ready to use your camera, including adjusting the neck strap, attaching the lens, loading batteries, and buying, loading, and storing film.

The Neck Strap

The neck strap is part of the camera's basic equipment and fulfills the important role of protecting the camera from being dropped. While you may protest that "this would never happen to me," It does happen often—even to experienced photographers.

Using a strap not only makes carrying your camera easier, it increases your readiness to shoot. Even changing lenses and reloading film is easier and safer if the camera is securely attached to your neck or shoulder. The length of the strap should match your body. Slip the end of the strap through the slotted strap eyelet from the outside and pull several inches through the slot. Now draw up the strap portion that passes through the black plastic buckle, slide the loose end of the strap through the retaining loop, and push the end of it up inside the buckle from below, so it passes from the lower buckle slot upward into the loop you made. Bend the end of it over inside the loop of strap and pass it back down through the other slot in the buckle; pull the strap taut. Repeat the process on the other side. Check the length; if it's too long, loosen the buckles and draw more of the strap through on the inner side until the length pleases you. There is no right and wrong strap length—just what is both comfortable and secure.

Attaching the Lens

When attaching the lens to the camera, line up the red dot on the lens with the red dot on the camera body. Then turn the lens clockwise until it stops. You must feel and hear the lens click (and

Insert the lens into the lens mount, aligning the red dot on the lens barrel with the red dot on the camera body, then turn the lens clockwise.

lock) into place. It's a good idea to gently try turning the lens counterclockwise to ensure it's locked in position. It shouldn't move at all. Remove the lens by pressing the release button and turning it counterclockwise. Since the lens' electrical contacts slide over the camera's, it is better to turn the camera off rather than leave on while changing lenses.

To remove the lens, press the release button and turn the lens counterclockwise.

Loading and Testing Batteries

The battery compartment is located in the Canon Elan 7/7E's handgrip. The camera requires two three-volt CR123A lithium batteries. Before installing them, the contacts on both the batteries and camera should be clean, dry, and grease-free. If not, use a clean dry cloth to wipe them off to ensure an optimal connection.

Batteries are checked automatically when the camera is turned on. The battery level is displayed on the LCD panel in any Program mode via the battery icon. A black icon indicates the

Pressing the release button in the direction of the arrow and swinging the door open gives access to the battery compartment.

batteries are full or at an acceptable level. As power dwindles, only the lower half appears black. At this point, the batteries don't have to be replaced, but you should have a spare set handy. Batteries can "recover," so you may see the icon indicating a full charge the next time you turn the camera on. Due to possible variations in the charge, the battery indicator's programming might display the "half full" symbol early. Batteries should only be replaced when the half-empty symbol or completely empty symbol starts blinking. In the latter case, the shutter button might lock. (See the accessories chapter for information on the BP-300 Battery Pack.)

Film

Film is a light-sensitive material that consists of an acetylene-celluloid base and a light-sensitive emulsion, which is multi-layered in color films. Exposing the film creates a latent image, which becomes visible only after processing as either a negative or positive image, depending on the film used. Film is available in positive or negative form and in color or black and white. The slide is a transparency that is the end product, while the negative is an intermediate product whose color and tonal values are the complements of the original. Paper prints can be made from negatives and slides.

Film Speed
The rated film speed is a measurement of its sensitivity to light and is stated as an ISO (International Standards Organization) number. ISO values are an arithmetic progression, in which each doubling of the ISO number indicates a doubling of the film's

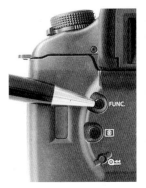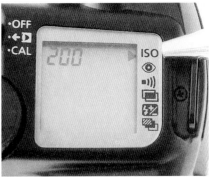

Check or change film-speed settings by pressing the function button until the arrow on the LCD panel points to ISO mark and the film speed appears on the monitor. Use the Main Dial to change the setting.

sensitivity; an ISO 200 film is twice as sensitive as an ISO 100 film and half as sensitive as an ISO 400 film.

The exposure index (EI) is the rating at which a photographer actually exposes a specific kind of film, therefore deliberately underexposing or overexposing it. This is done by changing the camera's or hand-held meter's ISO film speed setting to reflect a number different from the one recommended by the manufacturer.

Setting the film speed: In its default configuration, if the film is DX coded, the Elan 7/7E automatically sets the film speed for the built-in meter. For automatic control, you can use DX-coded films with speeds between ISO 25 and 5000. Check the set film speed by pressing the function button on the back of the camera until the arrow lines up with the ISO mark on the LCD panel.

You can set the film speed manually on the Elan 7/7E by pressing the function button (FUNC) until the arrow lines up with the ISO setting on the LCD panel, then rotating the Main Dial until you get the exposure index you want. If film will be exposed at a different sensitivity, such as when pushing film, press the function button until the arrow lines up with the ISO mark and the film speed is displayed on the LCD panel. You can now enter the film speed in the range from ISO 6-6400. When a film speed

is manually entered, the next film loaded will automatically be set according to its DX code, so if you use the same kind of film again, you'll need to reset its film speed.

Pushing film: If you find yourself in a situation where you want to make photographs but the light is too dim for the film currently loaded in your camera or in your camera bag, you might want to "push" your film and expose it as if faster film had actually been loaded. Start by using use the techniques for manually setting the film speed (tricking the camera into believing it has higher speed film than it actually does) to set it one stop (or more) higher than what the film was originally designated. When you do this you are no longer using the rated ISO film speed, but have set an exposure index for that particular roll—and it must be done for complete rolls.

Typically, film is pushed in multiples of a stop. For example, if you are using ISO 100 film and you want to expose it at an EI of 200, you will have pushed it one stop. The same ISO 100 film exposed at an EI of 400 is a two-stop push. With a permanent ink marker—an indispensable camera bag accessory—write "1 stop" or "2 stops" directly on the film cassette so you know to keep this film separate when having it processed. Then, be sure to tell your photo lab you want it to be pushed one or two stops. Using your instructions, they will overdevelop the film to compensate for the underexposure. Failure to adjust processing at the lab will result in totally underexposed images.

Pushing is not a panacea and can increase graininess and contrast. Depending on the film used, it can also cause color shifts. In general, the more stops you push the film, the greater the quality loss will be. Some types of films are more pushable than others, so check film specifications and read the camera magazines for this kind of information. In addition, color slide film is more pushable than color negative film.

Choosing Film
When selecting film from the range and variety of available choices, ask yourself: Do I want prints or slides? Color or black and white? There are no correct answers to these questions, only individual responses. Every photographer has their own ideas about what the photographic result should be.

Remember that choosing one type or brand of film is not a long-term commitment. One single film (negative or slide) can never fit every possible photographic situation. In addition, tastes change. You currently may enjoy shooting in black-and-white, but next year you may want to experiment with wildly saturated colors .

You can shoot in color and black and white, and expose both slide and negative film. Some photographers, however, advise that you shoot only negative film on one trip and slides on another; the reasoning is that you won't be happy if you look at half the shots from your vacation through a projector and the other half as prints. You might, for example, travel to the same destination many times over the years and want to combine the pictures from the various trips into a slide show or album. You will have a problem if you want to present a slide show about the United States but photographed the southwestern and southeastern United States as prints and the northeastern and northwestern United States as slides.

Photo excursions, though, are a different story. A short trip, even to your own downtown, is the perfect place to experiment with different kinds and brands of film. If something goes wrong, you can generally retake the shot in the next week or so and it won't matter if you have a few black-and-white shots mixed in with a bunch of color prints—and it could even add some variety to your photo album.

Keep in mind that flexibility is an asset in photography. You may prefer to shoot slide film when photographing wildlife and landscapes, but if a friend or relative asks you to make some snapshots at a wedding, baptism, or birthday, you'll be better off with negative film, since you'll want to make prints. You can, of course, get prints made from slides, but they cost more and are rarely better than those made from negatives, unless produced with the high-quality (and expensive) Ilfochrome process.

Selecting a film can also depend on what you like to photograph. In general, if you like making portrait images or nudes, you should select a film that offers good skin tones. For brilliant landscapes and detailed architectural shots, lower speed films can create dramatic images.

Wildlife and sports photography are often made under low-light conditions. Film speeds of ISO 400 in slide or in print film

are popular when working under mixed lighting conditions or with the relatively slow apertures of some telephoto zooms. For travel and vacation photography, the best all-round films are often those with ISO 100 or 200. But always pack a few rolls of ISO 400 or 800 color negative film just in case.

In summary, the advantages and disadvantages of various films are:

❏ Slide films have narrower exposure latitude than negative films and record a narrower range of brightness in a scene. They require more precise exposures than negative film; variations of even plus or minus one-third stop are noticeable.

❏ Negative films have a wide exposure latitude and record a wider range of brightness than slide film. They can be incorrectly exposed by as much as minus two stops or plus three stops and still produce usable prints. Color rendition as well as sharpness and brilliance of these prints ultimately depend on your lab.

❏ Low-speed films of ISO 25 to 50 tend to be fine-grained and sharp while offering high brilliance and color saturation, but have narrow contrast range and exposure latitude. Since the danger of camera movement is greater with these slower emulsions than with faster films, use a tripod.

❏ Medium-speed films in the range from ISO 100 to 200 tend to be fine-grained and sharp with good brilliance and color saturation. Their contrast range and exposure latitude are a good compromise between low- and high-speed films.

❏ High-speed films from ISO 400 to 3200 have coarser grain and can be less sharp as the film rating increases. More often than not, brilliance and color saturation are reduced as film speed increases, but contrast range and exposure latitude is greater.

Buying Film

If you aim for repeatable shots, it's a good idea to pick one type of film—for specific applications—and stick to it. But if you like experimentation, try a variety of films and then use the one that works best. Every now and then, it's fun to compare new films offering the latest "ultimate" emulsion with your regular film of choice. Shooting different kinds of film can bring back some of the joy and thrill often experienced by new photographers. So

while you may choose a favorite film for specific applications, don't hesitate to keep trying other choices that are out there.

Not all film, even from the same manufacturer, is the same. Films designated as "professional" usually differ from the amateur version in that emulsions are specially selected and aged to be delivered at their peak and exposed shortly thereafter. Amateur films are designed to withstand the vagaries of storage that are more likely to be encountered by the average user, which is why some travel photographers prefer amateur-labeled film to so-called pro stock.

It is immaterial whether you buy film at a large discount store or a small camera shop; what *is* important is proper film storage. It is usually better to buy film at home and not at the vacation spot, where it is more likely to be improperly stored and to be more expensive. One popular rule of thumb is to pack between two and five rolls of films for each day, depending on photographic zeal and destination.

Storage

Store amateur films in a cool, dark place. The best choice is the refrigerator; pack the film in a plastic bag to prevent moisture from getting to it. Unlike professional films, amateur films are not mature when shipped from the factory, and freezer storage halts this ripening process. Amateur films whose expiration date is six to eight months away can be stored in the freezer, as their emulsions are stable at this point. Once you remove film from the refrigerator, allow it to acclimate for two to three hours before being exposed, to prevent condensation buildup.

Exposed films should be developed as soon as possible to prevent changes in the latent image. If immediate processing is not an option, exposed films should be stored in a cool and dry place. Film should not stay in the camera for more than one day, particularly in the heat of summer.

Archiving Images

Store processed negatives and slides in a dark, cool, dry place. There are plenty of options when it comes to archiving: negative sleeves, pages, slide journals. No matter which storage option you choose, the most important consideration is to use archival materials that don't contain softening agents. Be careful when

using cabinets, because the glues, paints, varnishes, preservatives, and other solutions used can produce emissions that damage film.

Photo Labs

You will likely be bringing your films to a lab for developing prints and slides. Even though the two primary development processes (E6, C41) are standardized, there can be a noticeable difference between the quality of specific labs, particularly in color reproduction. Even the same lab can produce different results day to day.

When printing negatives, the differences are even greater. Prints from the same negative made on different days can exhibit different color characteristics and, depending on the operator, variations can even occur with expensive custom prints. You can minimize these variations by choosing a lab carefully and staying with the one with which you have had the best experience.

Film and X-rays

Store film in your carry-on luggage. One of the easiest ways to show security people your film is to place it in a transparent plastic bag.

Checked baggage is increasingly subject to x-ray examination using a combination of "hard" and "soft" radiation. Soft radiation is more damaging to films than conventional hard x-ray radiation. If security is using soft radiation you should always request—smile when you ask—manual examination, as the equipment will certainly ruin your film.

Modern airports in the United States are equipped with the latest x-ray equipment, which works with low doses of radiation and poses no danger to slow- or medium-speed films. In some countries, however, older x-ray units that can damage slower films are often still in use, and you should politely request manual inspection.

Infrared Film

To implement the quiet Whisper Drive found in the Elan 7/7E and other EOS bodies, Canon uses infrared LEDs instead of mechanical means to count the sprocket holes. Since the Elan 7/7E's LEDs operate in the infrared spectrum, Whisper Drive

cameras can possibly fog infrared-sensitive film. However, only a a certain few IR-sensitive films are affected by the Whisper Drive System, and even those films won't usually be fogged across the entire frame, but most likely along the outer edge of the sprocket holes.

Loading Film

Loading film is something you should be able to do almost with your eyes closed—particularly because you actually might have to reload your Elan 7/7E in the dark or a low-light situation some-time. Follow this procedure:

❏ To open the camera's back, push a small, recessed locking lever on the left edge of the Elan 7/7E's body. When you push it down, the back automatically pops open.

❏ Insert a film cassette diagonally from bottom to top in the left-hand side of the camera and press it flat with a finger to ensure it's secure.

❏ Pull out the film leader until it lines up with the orange mark at the opposite side of the open camera-back. Make sure the film lies flat and that its edges are parallel to the film guides so that it lies correctly within the film channel. If you pull too much film out, you may have to remove the cassette from its compartment again and wind the excess back in by turning the spool.

❏ After the back is closed and the camera is turned on, film will automatically advance to the first frame.

❏ If the film was loaded incorrectly, a cassette symbol flashes on the LCD panel and no number will appear in the frame coun-ter. You must then reopen the back wall and reload the film as previously described. Otherwise, the film cassette symbol and the number 1 will appear on the LCD panel.

❏ While the film is being loaded, if DX-coded film is being used, the film's ISO speed is also displayed. A frame counter showing the number of shots made as well as the cassette symbol are visible on the LCD panel, even if the camera is turned off. You can also know if film is loaded by looking through a small window on the camera's back.

Caution: *Handle film only in the shade—if necessary, shade pro-vided by your own body—and never in direct sunlight. Infrared*

To open the back, press the release button downward. The wall pops open automatically.

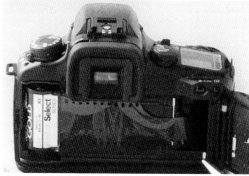

Insert the film cassette into the chamber diagonally from above and press it until it fits flush. Gently pull the film leader until it extends to the mark on the right side of the film compartment; make sure that it lies flat.

film should always be loaded in complete darkness, such as a light-tight closet or film-changing bag. Never touch the shutter curtains that are visible when the camera's back is open. Even the slightest touch could bend and ruin the shutter.

Reloading a partially exposed roll: Let's assume you want to rewind a 36-exposure roll of film after exposing the 15th frame. Before starting the manual rewind process, reprogram the camera using Custom Function 2 so the film leader is not wound into the cassette. The rewound film can then be loaded into the camera later as if it was a new roll, but you first have to make the following settings on the Elan 7/7E: set the camera in Manual Exposure (M) mode at the fastest shutter speed of 1/4000 second, select the smallest aperture, put the AF switch on the lens to M, cover the

eyepiece and the lens. Trip the shutter until you reach frame 16 or 17 (the so-called "safety frames"). At that point, you can continue your photography as usual.

Motor Drive Controls

Loading and rewinding film as well as advancing from frame to frame is done automatically with the Canon Elan 7/7E's motor drive. The film advance mode lever, located under the command dial, allows you to select between single and continuous modes in P, TV (Time Value), AV (Aperture Value), M (Manual), and Depth-of-field (DEP) modes. In Full Auto and any of the subject modes, the film advance option is fixed and cannot be changed.

Setting for single-frame transport.

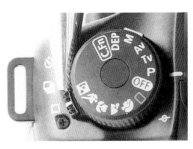

Setting for continuous transport.

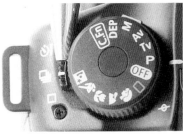

For most photographic applications, Single-frame mode is recommended. However, Continuous mode may be better for sports and action photography or for capturing a series of exposures of a moving subject. The maximum frame rate is four frames per second in AF One-Shot or Manual Focus mode. The camera will fire as long as the shutter button is held down. In

The button for midroll rewind.

AI Servo mode with focus tracking, the Elan 7/7E produces a maximum of 3.5 frames per second.

After the last frame is exposed, film is automatically rewound. The frame counter counts down and a moving bar indicates the rewind process. When the film is rewound, the motor stops and the cassette symbol flashes on the LCD panel. At that point, you can open the camera's back and remove the exposed film. You can rewind a partially exposed roll at any time by pressing the midroll rewind button located on the camera's back. Custom Function 2 allows you to program the Elan 7/7E so the film leader is not completely rewound into the cassette. Custom Function 1 has two rewind options: faster and louder rewind or slower and quieter rewind. Depending on how your camera is programmed, pressing the midroll rewind button during the rewind process switches to the alternate method (fast and loud or slow and quiet.)

Holding the Camera and Shutter Release Techniques

Solid camera support begins with your stance: when standing, keep your feet a shoulder width apart; when in a low camera position, place one knee on the ground. Keep your body relaxed. In this position, the camera is pressed against your nose and right eyebrow (for right-eyed shooters; left-eyed people are the reverse). For horizontal images, your head is slightly to the side of the camera and the lens' optical axis. Your right thumb lies in the molding between the lock button and the eyepiece; the right index finger rests on the shutter button. The other three fingers of your right hand grasp the Elan 7/7E's ergonomically designed handgrip. Your left hand should

The BP-300 handgrip is ideal for vertical shots. It is equipped with a shutter release and lock button for quick and comfortable firing.

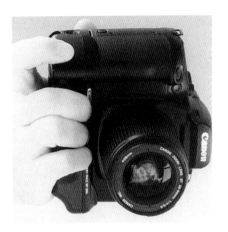

support the camera and lens from below. The bottom of the camera will rest on the ball of your hand as well as your little and ring fingers (both slightly bent). Your middle finger rests against the stationary part of the lens. Your thumb and index finger operate the zoom ring.

For vertical shots, your right elbow comes up without changing the position of your right hand on the camera. The narrow side of the camera now rests on the ball of your left hand. Your little and ring fingers, still slightly bent, rest on the bottom of the camera. Your middle finger rests against the stationary part of the lens. Your thumb and index finger operate the zoom ring. In the horizontal format, both elbows should be pressed onto your sides; in the vertical format, only the left one. One of the advantages of using the BP-300 battery pack accessory is that it includes a shutter button, AE lock button, and separate on/off switch, making vertical shots easier to hold and compose.

Shutter release technique is simple. Breathe quietly and hold your breath after exhaling. In this steady but relaxed position, you can now press the shutter button all the way down.

Rotate the camera 90 degrees to create a picture in vertical format. A handgrip, as shown above, makes it very easy to compose and shoot a vertical photo such as that on the opposite page. Photograph by Joe Farace.

35

Ready, Set, Snap!

Now it's time to try a little hands-on picture-taking:

1. While holding the lock button, move the program selector onto the green square (Full Auto mode) from the OFF position.
2. Aim the camera at the subject and touch the shutter button (don't press all the way down).
3. The active AF focusing sensor is displayed in the viewfinder. A green dot at the bottom right of the viewfinder display will light when an image is in focus.
4. The camera's built-in electronic flash will pop up automatically if required by the lack of adequate ambient light.
5. To take the picture, hold the camera steady and gently press the shutter button all the way down.

Focusing

Focusing is the process by which the focal plane is brought to coincide with the film plane by moving certain elements within the lens in the optical axis. An autofocus (AF) system provides automatic, motorized focusing, and the EOS Elan 7/7E offers one of the best AF systems in the world. The AF hardware used is a slightly different version of the technology used in Canon's top-of-the-line EOS 1V and EOS 3. The Elan 7/7E's software, though, offers some improvements not available even in those top models.

The camera's AF system is activated when the focus-mode switch on the EF lens is set to AF.

The Autofocus System

The Elan 7/7E's AF system is based on a CMOS sensor (Complementary Metal Oxide Semiconductor), which is also used in Canon's EOS 1V and EOS 3 models. As a later entry in the line, the Elan 7/7E benefits from improvements in software, particularly Eye-controlled Focus (7E only) and focus tracking. To turn the AF system on, all you have to do is slide the switch on any EF lens to AF.

The Elan 7/7E's AF system is passive, meaning it reacts to subject reflection and depends on the brightness and contrast of the photographic subject to function properly. With subjects that are too bright, too dark, or have low contrast, the AF system can fail. Smooth, monochromatic surfaces without identifiable structures

are other photographic subjects likely to cause AF error; structures in front of the actual subject, highly reflective surfaces, and backlight can also confuse the AF system. To overcome this problem, use focus lock or manually focus on a subject that's equidistant with your main subject.

AF Modes
The Elan 7/7E offers three AF modes: One-Shot, AI Focus, and AI Servo. Using the camera's AF switch, they can be activated in the Creative Zone modes—Program, Aperture-priority, and Shutter-speed Priority—as well as Manual Exposure mode. In Full Auto modes, the AF mode is determined by subject-related considerations and can't be changed.

One-Shot AF: Whether it's portraits, landscapes, or still lifes, most shooting will take place in One-Shot AF mode. Operation is initiated by lightly pressing the shutter button; the currently active focusing point will glow red on the viewfinder. Hold the shutter in this position until the in-focus indicator in the lower right of the viewfinder lights. Now you can press the shutter button all the way. If the in-focus indicator is flashing and the shutter button won't release, the AF system cannot focus on the subject area. This can occur for several reasons: the subject is closer than the lens' minimum focusing distance; the subject has very low contrast; the ambient light is too low; or the subject is highly reflective. One-Shot AF is integrated into the Portrait, Landscape, Close-Up, Night Scene, and Depth-of-field (DEP) modes.

The AF system can be set for 'One-Shot,' 'AI Focus,' or 'AI Servo.'

AI Focus AF: In AI (Artificial Intelligence) Focus AF mode, the Elan 7/7E uses One-Shot AF as its default setting with static subjects, but as soon as the camera perceives any movement in the viewfinder, it automatically switches to track and focus on the moving object. AI Focus AF is the default mode for Full Auto and Program AE modes.

AI Servo AF: AI Servo AF mode, with focus tracking and shutter priority, is perfect for focusing on a subject that is moving. As the camera perceives movement between the time of focusing and the moment before exposure, its computer predicts the position of the moving object at the actual time of the exposure. It adjusts focus accordingly.

Shutter priority takes precedence in the AI Servo AF mode when shooting in single-frame sequence. The camera will fire even if the subject is out of focus, since the assumption is that an out-of-focus image is preferable to a locked shutter button. That's why the sharpness indicator and audible signal are switched off and the active focusing point doesn't light in focus tracking.

Thanks to the number, position, and speed of its focusing points, the Elan 7/7E keeps focusing as long as the shutter button is partially depressed and the subject is moving. Although the initial point for tracking when using automatic selection is usually the center focusing point, the subject's movement is automatically tracked between all of the camera's seven focusing points. In a continuous sequence at 3.5 frames per second, the Elan 7/7E's AF system will even update focus between individual shots. However, when focusing points are selected manually or with eye control, the active focusing point will not change unless you choose to change it.

Selecting a Focusing Point
The Elan 7/7E is programmed with seven focusing points: one central focusing point, two vertical linear focusing points, and four horizontal linear focusing points. Their location is clearly marked in the viewfinder. This layout produces a large metering field with an arrangement of focusing points that can capture even off-center subjects.

Except during focus tracking, the currently active focusing point is indicated in the viewfinder and LCD panel. While the

The location of the seven AF System focus points is clearly marked on the ground glass of the viewfinder; the active focus point glows red. Custom Function 10 can be used to turn the glow off.

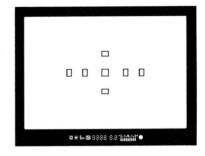

linear focusing points cannot capture subjects that run parallel to them, the central focusing point can handle anything regardless of orientation. Because it is a more sophiscated sensor than the others, the center point should be your first choice when working with difficult subjects.

This photograph is successful because the photographer placed the static subject off to one side, creating a dynamic composition.

Selection of the focusing point can be done automatically, manually, or through Eye-controlled Focus (with the Elan 7E) in Program, Depth-of-field, Shutter-speed Priority, Aperture-priority, and Manual Exposure modes. Manual selection of the focusing point is not possible in Full Auto or any of the Program modes.

The focusing-point button must be depressed to initiate the focusing-point selection process. The focusing point currently in use will light.

Automatic Focusing Point Selection

Automatic focusing point selection is active when all seven focusing points appear simultaneously on the LCD panel (set using the focusing point selector); the subject simply has to be within range of one or more of the seven focusing points.

Most AF cameras activate the focusing point that reports the shortest subject distance. In One-Shot AF, the Elan 7/7E does this too, but with more precision. If the focusing point that reports the shortest object distance is aiming at a narrow subject, the system automatically switches to a focusing point that can capture a larger object. This is intended to prevent focusing on objects in front of the subject, such as fences or small branches. If several focusing points find the same narrow subject, however, it will be the one item focused on, because it's assumed to be an important part of the composition.

Note: When looking through the viewfinder, you'll notice that the six linear focusing points are arranged in a cross-pattern around the central focusing point. This configuration may lead you to want to place the main subject in the middle of the frame, but this generally isn't the best way to compose a photograph; instead, place the main subject off-center in your composition.

The Eye-controlled Focus System (Elan 7E)

The Eye-controlled Focus (Eye-Control) system in the Elan 7E can be used with both One-Shot AF, AI Servo AF, and AI Focus AF, and with all picture-taking modes except Full Auto. This feature is

The switch for activating the Eye-control feature has three positions: off; Eye-control active; and Eye-control calibration.

activated when the Eye-control switch is set to On. All you have to do to track focus is follow the subject in the viewfinder with your eye as you press the shutter button halfway. As you do, the green eye icon appears in the panel underneath the viewfinder screen. This icon flashes if the camera fails to detect the focusing point you're looking at. Once the focusing point is detected, it will glow red (except in AI Servo AF). You can then push the shutter button all the way down.

Calibrating the Eye-controlled Focus System

To ensure optimal operation, the Eye-control system has to be calibrated before use. The Elan 7E has five channels to calibrate to the characteristics of five different people's eyes. Because Eye Control works so well with glasses or contact lenses, you can even use the channels for one person: one channel for use with glasses, one for sunglasses, and one without eyewear. When used

Setting for calibrating Eye Control.

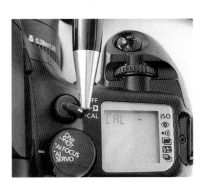

For this photograph, the low-center focusing point was automatically selected using the EOS Elan 7E's Eye-control feature.

with eyewear having specialized coating, mirrored surfaces, or thick glass, the system may not work optimally.

To calibrate the Eye Control:

❏ Turn the Eye-control switch to the CAL position; then, use the Main Dial to select one of the five calibration channels (CAL-1 to CAL-5). The number, which appears on the LCD panel and in the viewfinder, flashes if no calibration has been previously entered for this channel. It is important to register only one user per channel.

❏ First, with the camera in horizontal position, the far right focusing point starts flashing. Without turning your head, look at the flashing focusing point and press the shutter button; that focusing point stays on. The far left focusing point starts flashing next. Look at it and press the shutter button completely (it will not take a picture); the focusing point will stop flashing and stay lit. The same process is then repeated for the upper and lower focusing points. Successful calibration is confirmed when END-X appears on both the LCD panel and the viewfinder (END-1, END-2, etc., depending on the calibration channel selected).

❏ Using the same CAL position, turn the camera to the vertical position and depress the shutter button completely. The upper focusing point will start flashing, then the lower one, followed by the left and right focusing points.

❏ Focusing points in the camera automatically determine if you are holding the camera with the handgrip up or down. The top focusing point will therefore always be the one that lights first. You have to look at each flashing focusing point in turn and press the shutter button until they stop flashing. Completion of the calibration is indicated by END-X appearing on both the LCD panel and the viewfinder.

❏ To delete the calibration, turn the Eye-control switch to the CAL position, call up the channel to be deleted, and press the AE lock and AF selector buttons simultaneously. The cancellation is indicated on both the LCD panel and in the viewfinder by a flashing display of the channel. Pressing the shutter button restarts the calibration process.

❏ Once completed, you can repeat the calibration process as often as you wish by pressing the shutter button. If the camera cannot determine the position of your pupil, the display of the current channel will flash both in the viewfinder and on the LCD panel. You will then have to repeat the calibration process. To reactivate system control, simply turn the Eye-control switch to the Off position.

Achieving the most accurate calibration: To ensure the Eye-control system works optimally under different lighting and subject conditions, follow these suggestions:

❏ During calibration, avoid tilting your head, and don't move.

❏ Don't fixate on the flashing frame. Instead, look through it into the distance.

❏ Make sure there is no bright light source in the lens' path.

❏ When wearing glasses, make sure the glasses are seated properly and are not on an angle

❏ Keep your eye close to the eyepiece.

❏ Repeat the calibration under a variety of lighting conditions on the same channel. Use interior lighting, exterior sunshine, and hard contrasts, in the shade or under mixed lighting.

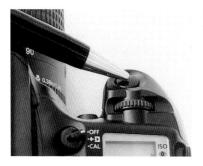

Pressing the shutter release half way locks focus.

Focus Lock

The seven focusing points cover a large portion of the viewfinder area, ensuring that a focusing point will detect off-center subjects. To capture an image, all you have to do is look through the viewfinder and trip the shutter. If you want to place the main subject further to the side or even lower in the interests of image composition, however, you'll need focus lock.

Aim the focusing point at the subject you want to focus upon. Touch the shutter button to initiate the focusing process and lock a focusing point. The AF focus indicator is on in the viewfinder display. Now you can take your time to select the desired composition while holding the shutter button or the lock button (*) and then pressing the shutter all the way down. Focus remains locked as long as you keep the shutter at its contact point or use the lock button. Focus lock only works with static subjects, using One-Shot AF mode and AI Focus AF mode.

The AF-assist Light

Because the Elan 7/7E's AF system is light and contrast sensitive, it might not be able to do its job at dusk or in candlelight. The AF-assist function, built into the manually or automatically flipped-up built-in flash, allows you to use the Elan 7/7E in complete darkness. If required, the flash emits a series of stroboscopic pulses when the shutter is depressed. Canon lists the range as 13.12 feet (4 m), but testing showed the range is closer to 26-32.8

feet (8-10 m) indoors in total darkness. The camera flash illumi-
nates only the angle of view of a 28mm lens, but can be used as
an AF-assist light with even extreme wide-angle lenses. Take care
when using a large lens hood since it might block the AF-assist
light. The AF-assist light can be used in all programs except land-
scape and sports modes. Using Custom Function 7, the AF-assist
light function can be turned off or transferred to an appropriate
accessory hot shoe-mounted flash.

**To focus manually, move the
AF/MF switch on the lens to
MF.**

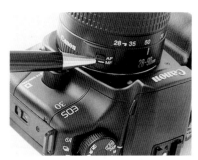

Manual Focus

Manual focus can be useful under certain lighting conditions. If
you're using any of Canon's tilt-shift lenses or accessories such as
bellows units, manual focusing is your only option. You can
focus manually using the viewfinder or by using focus assist. In
both cases, the AF/MF switch on Canon's EF lenses should be set
to MF.

Visually focusing by using the viewfinder can be done with
any lens except the new 28-200mm compact zoom. To focus,
turn the narrow focus ring on the lens until the main subject
appears in focus on the correctly calibrated viewfinder. Since you
can focus on any area in the viewfinder, this type of focusing is
excellent for careful image composition, making it easier to con-
centrate on the subject.

Manual focus with electronic assistance is precise and
equally easy to use. Focus manually while touching the shutter
button or pressing the AE lock button (see Custom Function 4).
When optimum focus is reached, the focus indicator on the bot-
tom of the viewfinder will light and one or more of the focusing

points may flash. This focusing method offers a high degree of precision. However, use care not to concentrate on the focus indicator instead of your subject. Train yourself to listen for the audible cue that sounds when the focusing point flashes. Because the focus indicator works only when the active focusing point is aimed at the desired subject area, you can manually select any focusing point. With difficult-to-focus subjects, the central focusing point offers the highest performance.

Manual Focusing Point Selection
To manually select a focusing point in Program, Aperture-priority, Shutter-speed Priority, Depth-of-field, DEP, or Manual Exposure mode, press the focusing point selector button. Then use the focusing point selector keys on the Quick Control Dial to choose the desired focusing point. You can reprogram the focusing point selector button using Custom Function 12 so that touching the key selects the central focusing point.

Hyperfocal Distance
The hyperfocal distance is the distance from the film plane to the start of the focus range when set to infinity at a given aperture. This is important when composing with depth of field in mind and as a snapshot setting in Manual Focus mode. A 50mm lens set at f/16 has a hyperfocal distance of 15.39 feet. Focus the lens at infinity and the depth of field extends from 15.39 feet to infinity. If you focus the 50mm lens at 15.39 feet, the depth of field stretches from 7.69 feet (2.345 m) to infinity. In practice, just line the infinity symbol (∞) up with the mark for f/16 on the lens' depth-of-field scale.

Metering

Metering Basics

The Canon Elan 7/7E has three metering modes: Evaluative, Partial and Centerweighted averaging. Each mode offers different characteristics to assure correct exposure in a variety of photographic situations. Under average and even slightly higher contrast lighting, the 35-zone Evaluative mode, which is integrated with the camera's seven focusing points, delivers correctly exposed images when shooting typical subjects. The system integrates metering information with data obtained from the AF system for correct metering in multiple situations in either vertical or horizontal compositions.

The Elan 7/7E also offers versatility. The experienced user can either select manual exposure or meter a specific subject element to adjust the exposure to fit specific creative moods.

The location of the 35 metering sensors in relation to the seven automatic focusing points.

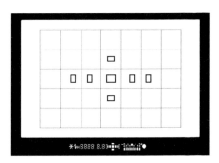

Evaluative Metering

In the Elan 7/7/E's evaluative metering system, the image area is divided into 35 metering zones, arranged in a grid pattern. Each zone is separately metered, and a microchip analyzes data on subject contrast and distribution of illumination. Because of the large number of metering zones, illumination over the entire image can be evaluated with a high degree of precision.

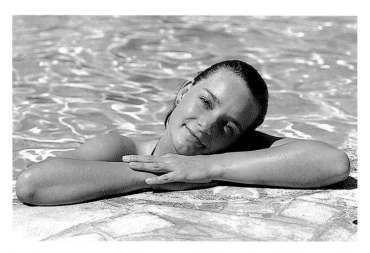

Despite the water reflections in the background, evaluative metering produced the correct exposure.

With autofocus, the location of the seven main metering fields corresponds to the position of the seven focusing points. The metering field that corresponds to the active focusing point is considered the main metering field; sensors adjacent to the main metering field become secondary metering fields. The remaining sensors are used primarily to calculate a balanced exposure for the background. If several sensors are activated, the metering area is expanded accordingly.

The distribution of the metering zones, their number, the camera's software, and the weighting of the exposure according to the focusing points are designed to produce a correct exposure in both vertical and horizontal formats. Even in difficult lighting situations, evaluative metering reacts quickly and accurately, but high contrast and strong backlight can confuse even this advanced metering system. Depending on the extent of the contrast, some backlit situations are automatically handled, but the photographer doesn't receive information about the extent of the correction and therefore does not know how much the back-lighting has been corrected.

In Full Auto and Programmed Image Control modes, evaluative metering is the Elan 7/7E's default setting. It can also be manually

selected in any of the Creative Zone modes using the metering mode button and the Main Dial. When focusing manually, only the center focusing point is actively linked to the evaluative metering system.

The metering area for partial metering corresponds roughly to the placement of the five central automatic focusing points.

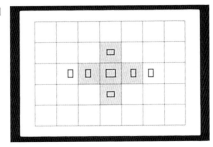

Partial Metering

Some photographers might call it spot metering, because it meters only a portion of the scene. But in general usage, most spot meters are limited to a small percentage—such as 4% to 7%—of the image area. Because Canon's system for the Elan 7/7E covers 10%, it's more accurately called partial metering. Custom Function 8 can be used to couple partial metering with the active focusing point.

In partial metering, the five central zones of the evaluative metering system—the center zone and each of the directly adjacent zones above, below, right, and left—are used. The ratio of metered area to total viewfinder remains constant regardless of the lens being used, but the partial metering angle decreases proportionally to the lens' angle of view. In other words, the angle decreases with increasing focal length.

Partial metering makes it possible to measure significant details in the composition and is useful with backlit situations, subjects in front of light or dark backgrounds, and other unusual or difficult lighting conditions. When used with lens focal lengths longer than 70mm, partial metering allows small subjects to be measured from a distance. Exposure lock should be used when the metered subject is off center or not within the range of the metering zones.

Partial metering can be used in Program, Aperture-priority, Shutter-speed Priority, Depth-of-field, and Manual Exposure

modes. To activate it, press the metering mode button and turn the Main Dial to select the appropriate icon on the LCD panel.

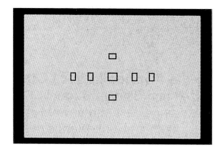

In centerweighted averaging metering, the entire image area is measured but the central area is given more emphasis.

Centerweighted Averaging Metering

In centerweighted averaging metering, though the entire image area is measured, the central area is weighted more heavily. It is an ideal mode for subjects having a normal contrast range, no significant color contrasts, and even distribution of light and dark areas. While not as sophisticated as evaluative metering, it allows you to interpret results quite accurately with a bit of practice. This is especially important if you wish to depart from the metered value when making manual exposure corrections.

Centerweighted averaging metering can be used in Program, Aperture-priority, Shutter-speed Priority, Depth-of-field, and Manual Exposure modes. To activate it, press the metering mode button and turn the Main Dial until the desired symbol appears on the LCD panel.

Exposure Lock

When the Elan 7/7E is set for One-Shot AF, exposure is locked along with the focus setting when the shutter release is partially depressed, but the lock button (*) can also be used to lock exposure independent of focus.

To use exposure lock, aim the partial metering zone (central or coupled to the focusing sensor) at the subject to be metered. Press the lock button to store the exposure value. The metered value, which is identified by an asterisk on the LCD panel,

The AE lock button allows you to lock the exposure without affecting focus.

remains locked for four seconds. If you need more than four seconds, hold the lock button down with your thumb. Since the exposure value is recorded the moment you press the lock button, it's important to aim the metering zone at the desired section of the image—no matter which exposure method you're using. It is critical to use partial metering with exposure lock to measure exposure off a substitute subject, such as a gray card

The KODAK Gray Card

A KODAK Gray Card is frequently used as a target for metering, because it closely matches an average midtone and is constant from one card to another. Rather than taking a reading off of rocks, tree bark, grass, and other approximate midtones, using a Gray Card, which reflects precisely 18 percent of the light, eliminates the guesswork. Place the card in the scene you plan to photograph in the same light as your primary subject. Move close enough to the card so that it fills the designated metering area (partial metering works best), taking care not to shade the card with the camera or your body. Tilt the card slightly so it does not reflect glare. Take a meter reading from the card in the camera's Manual Exposure mode, or use AE Lock to lock in the exposure

Kodak recommends that you adjust the meter readings as follows: For subjects of normal reflectance, increase the indicated exposure by 1/2 stop. For light subjects, use the indicated exposure; for light-colored subjects, decrease exposure by 1 stop. If the subject is dark, increase the indicated exposure by 1 to 1-1/2 stops.

A KODAK Gray Card is a useful exposure aid, particularly with subjects of unusual reflectance or lighting.

Manual Exposure Corrections

There are lighting situations that confuse the most refined exposure metering system, and manual exposure correction gives you the opportunity to make deliberate changes to the camera's exposure system without affecting the convenience of automatic controls. Manual exposure corrections are recommended with subjects in high contrast and/or strong backlight, and also when a given lighting mood is desired. On the beach in bright sunshine, in snowscapes, or under strong backlit situations, corrections of from +1/2 to +2 stops might be necessary, depending on the lighting situation. Darker subjects may require negative adjustments. Caution, however, is advised when photographing at night or under dark conditions. If exposure times in excess of one second are indicated, the failure of

Manual exposure corrections are entered by setting the Quick Control Dial to on.

The picture on the top was taken using evaluative metering. Due to the strong backlight, these columns are underexposed. The photo on the bottom, taken with a manual exposure correction of +1.5 EV, is a better overall exposure.

reciprocity becomes evident — which, in turn, can make it necessary to increase exposure time even more.

Reciprocity means that equivalent exposures can be created by making adjustments to both the intensity and duration of light allowed to strike the film. An exposure at f/5.6 and 1/30 second is equal to an exposure at f/4 and 1/60 second, and also equal to one at f/11 and 1/8 second. But this principle does not generally apply to exposures of one second and longer. To counter this failure, exposure time needs to increase more than what reciprocity would normally call for. An exposure metered for five seconds might have to be extended to 20 or more seconds in order to achieve an acceptable image. When using color film, it is often necessary to add filtration to create natural looking images. The film manufacturer's data sheet usually lists reciprocity characteristics of its products.

Manual exposure corrections are available in Program, Aperture-priority, Shutter-speed Priority, and Depth-of-field modes. To make an exposure correction manually, hold the function button and enter the desired manual correction by rotating the Quick Control Dial. (To prevent making changes when you

don't mean to, lock Quick Control Dial with the off/on lever just below it.) You can enter corrections between –2 and +2 stops in 1/2-stop increments. The correction value selected is displayed on a scale on both the LCD panel and the viewfinder. To cancel the correction, press the function button and rotate the Quick Control Dial to enter a zero value. Turning the camera off or turning the selector to Full Auto or any of the Program modes will not cancel the correction.

High-key Photographs
High-key shots consist primarily of white and light subjects in front of light-colored backgrounds using shadowless lighting. This technique is often used in portraits, still lifes, and nudes. To increase the effect, use manual corrections of +1 or +2 stops to deliberately overexpose.

Low-key Photographs
Low-key shots consist of darker colors or grays that show little detail. Low-key shots often create an ambience or mood by using dark main subjects in front of a dark background with minimal lighting. Deliberate underexposure of –1 or –2 stops can, depending on the subject, increase the effect. Catchlights, or highlights in the image, increase the effect and add to the drama and suspense.

To shoot photos such as fire-works, manually set a long exposure time (5-15 seconds).

Beyond Exposure Metering

Some subjects, such as fireworks or lightning, cannot be measured by any traditional exposure metering system. With fireworks, manually set the exposure time to somewhere between six and 15 seconds and point the camera toward the fireworks. If you want to photograph lightning, switch from AF to MF, go to Manual Exposure mode (M) and then select Bulb mode using the Main Dial. With these settings, the shutter stays open as long as the release is depressed. Because this increases the danger of camera movement, though, mount the Elan 7/7E on a sturdy tripod and use a remote release device such as the Remote Switch RS-60E3 accessory or wireless Remote Controller RC-1 accessory. For more information, the publication *KODAK Professional Photoguide* contains existing light exposure dials with suggested starting apertures and shutter speeds for different kinds of film.

Automatic Exposure Bracketing

Automatic Exposure Bracketing (AEB) is a useful technique for making a sequence of exposures consisting of the metered exposure, underexposure, and overexposure. Film consumption increases with use of bracketing, but film is usually the least expensive aspect of any kind of photo outing or vacation

To activate automatic exposure bracketing, press the function button until the arrow on the LCD Panel is at its lowest position. Then, use the Main Dial to select the desired difference between the exposures.

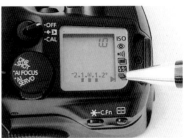

The Elan 7/7E's AEB function can be used in Program, Shutter-speed Priority, Aperture-priority, and Depth-of-field modes. To activate AEB:

❏ Press the function button until the arrow on the LCD panel is opposite the lowest mark, identified by the appropriate icon

(overlapping images). Then use the Main Dial to select the exposure interval between the images. You have a choice of ±2 stops in 1/2-stop increments. The intervals are indicated on the exposure correction scale in the viewfinder and on the LCD.

❏ The index for the current exposure flashes in both the view-finder and the LCD panel during the bracketing operation. The symbol for exposure lock (*) also appears in the viewfinder during the process. If you do not complete the exposure bracketing, all three indices as well as the function arrow start flashing.

❏ The bracketed shots can be taken using single or continuous film advance modes. In single-shot mode, you simply have to press the shutter release for each of the three exposures; in continuous mode, the three shots are taken sequentially while you depress the shutter button.

❏ To cancel AEB, enter a value of zero. As with exposure compensation, it won't cancel if you turn the camera off or move the Command Dial to Full Auto or Program mode. Since AEB doesn't work with flash, flipping the built-in flash will also cancel the operation.

For bracketing with a constant shutter speed, use Shutter-speed Priority or Manual Exposure mode. Bracketing with constant aperture can be done in Aperture-priority or in Manual Exposure mode without AEB.

Automatic exposure bracketing should not be confused with taking many shots in the hope of getting one of them right. When correct exposure is the goal, though, AEB is often the best option available—even to professionals.

Slide film: With slide film, a bracketing series might consist of three (automatic) exposures with intervals of 1/2 stop, but AEB doesn't have to start at the normal exposure. On the EOS Elan 7/7E, AEB can also be done in conjunction with manual exposure corrections. You can shift the entire series of bracketed frames in the direction so that, for example, backlit scenes are bracketed only on the plus side. Here's how it would work if you were to combine an AEB interval of one-half stop with a manual exposure compensation of plus one stop:

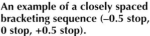

An example of a closely spaced bracketing sequence (–0.5 stop, 0 stop, +0.5 stop).

First frame ("normal")
= +1 stop
Second frame (under)
= +1/2 stop
Third frame (over)
= +1-1/2 stops

This bracketed series covers a range of overexposure in small increments without wasting film on underexposed frames.

Some photographers suggest that a slide projected by a 150-watt lamp should be a touch lighter than a slide projected by a 250-watt lamp, while a slide that will be scanned for publication should be about 1/2 stop brighter than a slide destined for projection. One technique is to shoot for what looks good on a color-corrected lightbox.

Exposure Modes

The Canon Elan 7/7E is equipped with 11 different exposure programs: six Image Zone program modes for those who want completely automated picture taking; and five Creative Zone program modes for those who want to take advantage of creative options including manual operation. These choices allow you to experiment no matter what your level of photographic skill may be.

Letters and icons on the Command Dial identify the exposure programs, giving you quick, easy access to them. To activate any exposure mode, turn the Command Dial until the mode identifier lines up with the index mark on the camera body.

Basic Zone Modes

The Basic Zone modes consist of Full Auto plus the Programmed Image Control Zone, Portrait, Landscape, Close-up (Macro), Sports, and Night Scene subject modes. The Elan 7/7E automatically determines camera settings for all these modes. Ideal for beginners, the subject modes are designed to create professional-looking photographs that are optimized by the camera for the kind of conditions often found in the special applications.

The Basic Zone modes override the camera's Main Dial, Command Dial, and AF mode dial, the film advance mode lever (except for the self-timer and remote control), and the camera buttons (except for the function button, mid-roll rewind button, and the shutter button). All manual controls are locked, and the depth-of-field preview button can't be used. Except for Landscape and Sports modes, the camera's built-in flash pops up and fires automatically in backlit or low-light situations.

In Basic Zone modes, just press the shutter button all the way to take the picture.

Full Auto Mode
In Full Auto mode, the Elan 7/7E uses evaluative metering, single-shot film advance, automatic focusing point selection, and

Setting for Full Auto mode.

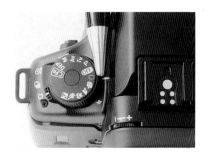

AI Focus AF, with automatic switching to AI Servo AF if the camera detects subject movement. Options in this mode include focus lock, manual focus, and the self-timer. You can activate Eye-controlled Focus (7E) to select the focusing point, red-eye reduction, and audible signals, but other functions, such as program shift, manual exposure correction, or selective metering, are blocked. The viewfinder and LCD panel display all data relevant to exposure, such as shutter speed, aperture, and flash status.

Full Auto mode is well suited to subjects that have little or no movement; if you want to freeze motion or produce portraits with soft, blurry backgrounds, exposure modes such as Sports or Portrait might be better choices. When using flash, make sure the main subject is within flash range. In non-flash situations, focus on the subject by aiming the desired focusing point at it, then lock the focus by holding the shutter button partway down.

Snapshots: Natural, spontaneous images can be more expressive than staged or posed shots. Opportunities for creating snapshots arise out of a particular situation and can capture a funny scene or convey spontaneous feelings. You can anticipate such opportunities by observing a scene and waiting for certain situations to arise. This requires fast reaction times and a state of readiness—conditions in which Full Auto mode is the best choice.

Portrait Mode
One of the characteristics of a professional portrait is a focused face (specifically the eyes) and an out-of-focus background.

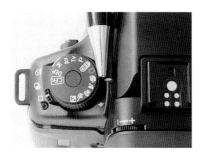

Setting for Portrait mode.

Portrait mode is specifically designed to blur the background so the subject is in focus and stands out.

In Portrait mode, the Elan 7/7E works with one-shot AF, automatic or Eye-control (7E) focusing point selection, evaluative metering, and continuous film advance. Partial metering, manual exposure correction, and automatic exposure bracketing are not possible.

Portrait mode works best with fast lenses that have focal lengths of 80mm or longer; particularly appropriate are lenses with focal lengths between 80mm and 135mm. Candid portraits are best made at longer distances using telephoto lenses with focal lengths between 180mm and 200mm. Unless equipped with image stabilization (IS), longer lenses increase the danger of camera shake when the camera is handheld.

To achieve minimal depth of field, Portrait mode selects the largest aperture on the lens or the selected zoom position in use, and a shutter speed up to 1/4000 second. If there is too much light for the fastest shutter speed, the aperture will be stopped down.

If you are using long, fast lenses to make full-frame head shots or tighter compositions, you might find that the tip of the nose is in focus but the eyes are not. An established technique is to focus on the eyes, lock focus by holding the shutter button halfway down and then return to your original composition.

To avoid a static look in your portraits, involve the subject in conversation and wait for the right expression before pressing the shutter button all the way to take the picture. The biggest difference between good and bad portraits is in the subject's eyes. Taking the time to speak with your subject to relax him or her will help create a portrait that satisfies both of you. This

technique may be difficult when using the red-eye reduction function, because of the four-second wait between pressing the shutter button and capturing the actual exposure. During this time, watch the subject's expression and be prepared to react to any change. You can always press the shutter button a few seconds after the function is complete.

Portrait film: Films differ in how they realistically render skin tones. Specialized negative films that concentrate on producing natural, pleasant skin tones have been developed specifically for the professional portrait market. Most portrait films have a soft, even gradation from highlights to shadows, which means that these films are good not only for portraits, nudes, or wedding photography, but also for landscape images, if subtle nuances are your goal.

Setting for Landscape mode.

Landscape Mode
The trademarks of a traditional landscape image are wide angles of view and extremely sharp focus, which is why the Elan 7/7E's Landscape mode is designed for short focal lengths and increased depth of field. This is the opposite of Portrait mode, which is designed for longer focal lengths and limited depth of field.

In Landscape mode, the Elan 7/7E uses evaluative metering, single-frame film advance, one-shot AF, and automatic focusing point selection; on the Elan 7E, Eye-controlled Focus can be

This sunny portrait draws the viewer into the model's face. In order to keep the eyes in sharp focus, select the focusing point for that specific area. This is especially important for a head-and-shoulders shot. Photograph by Joe Farace.

63

Both shots demonstrate the effect that control of depth of field has on ⟳
the final image. The black-and-white shot was taken at f/5.6. The selec-
tive focus combined with the shallow depth of field isolates the statue
from the background. The color shot was taken at f/22, which yielded
greater depth of field making the background an equally important part
of the image.

Above: When on vacation, don't miss opportunities to photograph details such as those seen in this study of doors. Such fine points often capture a place and are good subjects for framing when back at home.

An image stabilizer reduces the risk of camera shake. These photos were taken with a 28-135mm image-stabilized lens. The depth-of-field preview button was used to make sure the image was sharp where required.

◁ A Canon EF 20mm f/2.8 lens with Tiffen® circular polarizer and Land-
scape mode were used for these photographs of the Grand Canyon.

69

A typical shot in Landscape mode, using a 24mm wide-angle lens to extend depth of field.

activated to select a focusing point. Since most landscape subjects are located near infinity, the camera's flash and AF-assist light cannot be used. Powerful shoe-mount accessory flashes, such as the Speedlite 420EX or 550EX, offer flash and AF-assist functions in Landscape mode, but this mode is not really designed to use flash. As in all subject programs, partial metering

Page 70: One advantage of a zoom lens, such as the Canon EF 28-135mm, is that you can easily change the framing of your subject. The top photo, taken with a short focal length, shows a suburban setting with a river and shopping center. The lens was then zoomed to a longer focal length to take this tight shot of the water tumbling over the rocks. Photographs by Joe Farace.

Page 71: If a scene appeals to you take the picture, even if you aren't sure what you like about it. This vacation snapshot is an interesting study of shapes, colors, and opposition. Notice the juxtaposition of sunlight against shadow, straight lines and sharp angles against the curve of the arch, and cool blue against warm tan.

Page 72: Sunlight coming from overhead added shadows to the shallow relief carving, accentuating its intricate detail. To reveal the tactile qualities of textured objects, the light source should skim across the surface from an angle.

and manual exposure correction can't be used—they could cause problems with strong backlight or high-contrast subjects.

To make effective use of Landscape mode, choose lenses that have wide angles of view or zoom lenses with wide-angle settings. You can use Landscape mode with 35mm or 50mm lenses, but lenses with focal lengths between 20mm and 28mm offer greater depths of field even at maximum aperture. Stopping down increases depth of field.

The wide-angle characteristics of lenses decrease with increasing focal length, but detail shots made with longer lenses are also part of landscape photography. Unfortunately, Landscape mode doesn't allow for this option. With the small aperture required for long depth of field, shutter speeds become slower, increasing risk of camera movement. When that happens, the shutter speed flashes in the viewfinder as a warning.

Incorporating the foreground: Landscape mode is designed for overview shots using wide-angle lenses. Using focus lock while holding the shutter button halfway down or with manual focus lets you include parts of the foreground in your composition. A combination of wide-angle lenses and Landscape mode emphasizes depth of field, allowing you to take great shots with monumental foregrounds and vanishing backgrounds.

Setting for Close-up mode.

Close-up (Macro) Mode

Close-up mode is designed for a zoom lens' macro setting and specialized macro lenses like the EF 100mm f/2.8 USM. The Elan 7/7E uses single-frame transport, one-shot AF, and automatic focusing point selection (the 7E's Eye Control is also an option for focusing point selection) in this mode.

Close-up mode will yield good image quality and acceptable reproduction ratios for subjects at close ranges.

The 100mm f/2.8 USM's maximum aperture of f/5.6 is typically selected, making the characteristics for Close-up mode similar to Portrait mode. This is a compromise made to limit blurring caused by camera movement that is often amplified at an intimate camera-to-subject distance. But more depth of field is typically needed for this kind of photography, so a wide aperture may not be the best choice. In order to stop down to gain greater depth of field, more light would be needed. At a reproduction ratio—the relationship between the size of an object and its size on the finished film frame—of 1:1 at f/5.6, the depth of field covers only one millimeter. That may be why the camera's built-in flash usually pops up when a smaller aperture is selected to go with a flash sync speed of 1/125 second.

Even with a program specifically designed for close-up and macro photography, it can be tricky to produce the kind of eye-popping images usually seen in nature magazines. As the reproduction ratio increases, the lens extension increases and depth of field shrinks, requiring you to stop down. A combination of lens extension and small aperture produces longer exposure times, which is why the built-in camera flash can be important in close-up work. Evaluative metering generally takes care of balancing the exposure between the foreground and the background. When shooting close-ups of stationary subjects, it's a good idea to use a tripod to eliminate camera shake.

Using flash reduces the risk of camera shake and adds sparkle to the shot. Subjects, such as insects, can be captured in focus with adequate depth of field. Under tricky lighting conditions, the built-in flash acts as an AF-assist light and fires a brief burst of flashes when you depress the shutter button halfway. Be careful that the long lens extension or lens hood doesn't block the flash. The Off-camera Shoe Cord 2 accessory lets you place a flash, such as the 420EX, up to two feet (0.61 m) from the camera. This not only moves the light away from any interference but also adds dimensionality to the image, eliminating the flat look associated with direct on-camera flash. If you want soft, shadowless light, you might want to invest in the MR-14EX Ring Lite accessory.

Sports Mode

Photographing sports can be a challenge. The subjects are in motion and, with the long lenses that are typically used, camera shake can be a problem. That's why Sports mode is biased toward short exposure times. When lighting conditions and the lens' maximum aperture permit, the camera selects a shutter speed faster than 1/250 second. Fast shutter speeds freeze motion and minimize the possibility of camera shake resulting from the use of long telephoto lenses.

You can take professional-looking sports shots with the Canon EOS Elan 7/7E in Sports mode.

76

To make it easier to follow moving subjects, Sports mode uses AI Focus AF (tracking focus) mode, evaluative metering, and continuous film advance; with the Elan 7E, you can activate Eye-Control focusing point selection. The fast shutter speeds and tracking autofocus of Sports mode is not limited to sports and can be useful for wildlife in motion or children at play.

While the shutter button is held halfway down, the Elan 7/7E's AI Focus AF mode tracks or follows moving subjects, but first you have to aim the central focusing point at the main subject. The other focusing points focus on the subject as soon as it moves past the central focusing point. Flash cannot be used in this program because the shutter speeds of 1/250 or 1/500 second, required to record action, are too fast for the frame to recieve full flash exposure. One creative use of flash, with the Speedlite 420EX or 550EX accessory flash unit, combines electronic flash with a longer exposure time to produce blurred movement with a hard-edged flash center.

To make sure that Sports mode selects fast shutter speeds, you need good lighting and fast lenses. Under low-light conditions, ISO 400 or films can be used; you can use faster films up to ISO 800, for example, without losing too much image quality. When in doubt, it is better to choose larger grain and somewhat lower color saturation than out-of-focus photographs.

When using a longer focal length lens, a tripod or monopod will reduce camera shake but can limit your freedom to follow moving subjects. A Canon zoom lens, with long focal length and image stabilization (IS), on the other hand, offers complete freedom—as long as you have strong biceps. Even when using IS lenses, your shutter speed has to be fast enough to stop movement.

Panning: While Sports mode is biased toward short exposure times to stop movement, there's a technique, called panning, in which the object is captured in focus but the background is blurred. This can increase the appearance of movement in the image and create a dynamic effect. During panning, the camera is moved along with the subject, parallel to it and in the same plane. The shutter speed depends on the subject's movement and should be too long rather than too short. When in doubt, set a shutter speed between 1/60 and 1/15 second in Shutter-speed Priority or Manual Exposure mode.

Night Scene mode's slow sync flash function produced correct exposure of both the main subject—the novice—and the surrounding area.

If there is a trick to this technique, it is to begin the pan *before* you depress the shutter button all the way, and then keep panning. This will keep your panning motion smooth without any wobbles caused by starting and stopping camera movement. Since your success rate can't easily be determined when shooting, it is a good idea to make several shots. Of course, it always helps to practice the technique in advance. Finally, Canon's new IS lenses even offer a mode specifically designed for panning.

Night Scene Mode

Night Scene mode is designed for taking pictures of people at twilight or night. By incorporating flash to illuminate the subject along with a slow shutter speed, background color and detail are maintained. This is great for vacation photography or anytime you want to show a person in the context of nighttime surroundings. With a portrait made in front of an illuminated cityscape or sunset, the foreground or the background will be exposed correctly, but it's less likely you will achieve a balanced exposure between foreground and background. Night Scene mode automatically selects a long exposure time to go with flash illumination so the background will have sufficient exposure. The flash accurately illuminates the main subject in the foreground, while the background is exposed properly by the shutter speed.

In Night Scene mode, the camera's flash automatically pops up and performs its AF-assist function in total darkness. You can even activate the red-eye reduction function by pressing the function (*) button. One-shot AF, automatic focusing point selection (and, in the 7E, Eye-control focusing point selection), single-frame film advance, and evaluative metering are compatible with this mode. Manual exposure correction and partial metering are not possible in Night Scene mode.

Night Scene mode works with any EOS system-compatible flashes and is not designed for a specific focal length range, so you can experiment with any lens. Keep in mind that camera shake, particularly with long lenses, is possible. A tripod can be helpful in preventing camera shake, but it should not interfere with the spontaneity of picture taking; instead of a tripod, consider using an image-stabilized lens or high-speed film (ISO 400 or 800) as an alternative.

Creative Zone Modes

The modes in the Creative Zone—Program, Aperture-priority, Shutter-speed Priority, Manual Exposure, and Depth-of-field—give you more picture-taking control because they allow you to change the aperture and/or shutter speed to achieve the photographic effect you want. The following features of the Elan 7/7E work in the Creative Zone modes: AE lock, autoexposure

bracketing, multiple exposures, Bulb mode exposure, exposure compensation, manual setting of film speed, film advance mode selection, depth-of-field preview, and mirror lockup.

Position for Program mode.

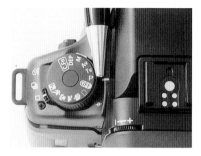

Program Mode

In Program (P) mode, depending on subject brightness and lens focal length in use, the Elan 7/7E's computer automatically selects a suitable shutter speed and aperture.

The photographer chose program shift when shooting this photo to attain a smaller aperture that would extend the depth of field.

All of the Elan 7/7E's functions are available in P mode, including the three exposure metering methods, AF, and Film Advance modes, as well as manual exposure corrections, automatic exposure bracketing, and the self-timer; the depth-of-field preview button can be used to visually examine the depth of field in the viewfinder.

Program mode is ideal for candid shots. It is a perfect solution whenever you want to make images without thinking about camera technology, providing instant readiness along with access to any desired manual options.

Program Shift: You can shift—change the shutter speed/aperture combination to satisfy your creative intentions—while maintaining proper exposure. The program shift option offers the possibility of changing the shutter speed/aperture combination while maintaining the exposure value. This is accomplished without affecting the convenience of automatic exposure control, allowing you to change the shutter speed/aperture combination in any of the program modes. Program shift gives you the option of combining the convenience and ease of automatic exposure control with the ability to apply creative concepts. You could use a smaller aperture for greater depth of field or a faster shutter speed in order to stop movement.

To use the shift option, turn the Main Dial while slightly depressing the shutter button, until the desired aperture or shutter speed appears on the LCD panel or the viewfinder. Program shifts are made in 1/2-stop increments (half aperture or half shutter speed). After each exposure, the shift option is canceled and the original program characteristics are reactivated. If you keep the shutter button depressed after the shot, or use Continuous Shooting mode, the shift stays active. Program shift doesn't work when the built-in flash is up or if an accessory flash is attached and turned on. If the subject is too bright, both displays start flashing the fastest shutter speed (1/4000 second) and the lens' minimum aperture. With subjects that are too dark, the longest exposure time (30 seconds) and the lens' maximum aperture will flash.

Shutter-speed Priority Mode
Once you turn Shutter-speed Priority (Tv, for time value) mode on by turning the Command Dial, you can use the Main Dial to

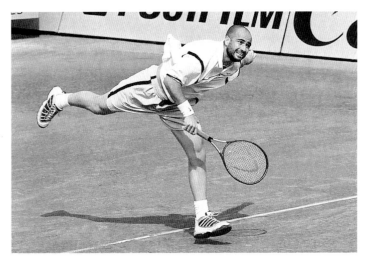

Fast movements require fast shutter speeds to freeze action. This photograph was shot using a shutter speed of 1/4000 second selected in Shutter-speed Priority mode.

select any desired shutter speed. When you do, the camera picks an aperture based on that shutter speed and the lighting conditions. On the Elan 7/7E, speeds between 1/4000 second and 30 seconds in 1/2-stop increments are available and are displayed in the viewfinder and the LCD panel. When Tv mode is turned on, the last shutter speed used in this mode is displayed.

Tv mode gives you control over whether subject motion is portrayed as sharp or blurred. When using telephoto lenses, the standard is to use shutter speeds that are the equivalent of the reciprocal of the lens' focal length. With a 300mm lens, 1/250 second makes a good starting point, although I typically set 1/500 second unless I'm using an image stabilization lens.

Make sure the available aperture range is sufficient to provide correct exposure at the selected shutter speed. If the lens' largest available aperture flashes in the viewfinder and LCD panel, the selected shutter speed is too fast for an adequate exposure. The Elan 7/7E will let you trip the shutter, but the resulting image will be underexposed. To prevent this, select slower shutter speeds

until the aperture number stops flashing, but be aware that longer exposure times increase the risk of camera shake. Depending on the focal length, you might want to use a tripod or rest the camera on something solid. If the main subject is within the range of the built-in or accessory shoe-mounted flash, such as the 420EX, turn the flash on. The exposure is then taken with the manually selected shutter speed as long as it is below the maximum flash synchronization speed; the camera automatically defaults to the speed of 1/125 second if the selected shutter speed is too fast for flash sync.

If the number corresponding to the smallest lens aperture is flashing in the viewfinder and LCD panel, the manually selected shutter speed is too slow for proper exposure even with the smallest aperture on the lens. The exposure will occur, but an overexposed image will result. Selecting a shorter exposure time usually solves the problem. If the fastest shutter speed of 1/4000 second is still too long, you will need to use a neutral density filter, such as those made by Tiffen.

In Tv mode, you can use all exposure methods and every camera function, including automatic focusing point selection, AF and film advance modes, as well as manual exposure correction, automatic exposure bracketing, self-timer, depth-of-field preview button, red-eye reduction, and multiple exposures. A recommended basic setting is evaluative metering, AI Servo AF, automatic focusing point selection, Eye-control Focus selection (7E) of the focusing point, and continuous film advance.

Tv mode is ideal for photographing subjects in motion, such as in sports and action photography. Depending on the shutter speed, movement can be sharp or blurred. By choosing a fast shutter speed, Tv mode will eliminate camera shake when using telephoto lenses. Another application is to shoot photographs from a television screen. These must be made at 1/15 second with the camera mounted on a tripod.

Shutter Speed and Movement: Even when using tracking focus, if your shutter speed isn't matched to the subject's movement, some amount of blur will be seen in the image. The direction of motion is also important. If you want to capture a person walking at an average pace at a distance about 16 feet (5 m) from the camera, use the following shutter speeds:

- ❏ 1/500 second for movement perpendicular to the optical axis
- ❏ 1/250 second for movement on a diagonal
- ❏ 1/125 second for movement parallel to the optical axis

If the object is moving faster, shutter speeds have to be correspondingly shorter. If you want to depict blurred movement, use longer exposure times.

Time Exposures: Slow shutter speeds are useful when shooting fireworks or city skylines at night. Night shots, starry night skies, or multiple exposures with an open shutter are other applications for time exposures.

There are two ways to make time exposures with the Elan 7/7E—automatically and manually. In Tv mode, you can select shutter speeds up to 30 seconds, and the camera automatically selects an aperture. Conversely, selecting a small aperture under poor lighting conditions in Aperture-priority mode ensures that the camera automatically picks a long exposure time. In Manual Exposure (M) mode control, you can select a long exposure time, but—unlike Tv mode—you also must choose an appropriate aperture.

Bulb Setting: Because the Elan 7/7E offers a Bulb setting, you can use Manual Exposure mode for exposure times longer than 30 seconds, making exposure times of several hours possible. In Bulb mode, the shutter stays open as long as the shutter button is pressed. The Bulb setting is at the end of the shutter speed series after the 30-second setting. In place of a shutter speed, the word "*buLb*" appears in the viewfinder and on the LCD panel. Pressing the shutter button all the way trips the shutter and "*buLb*" flashes on the LCD panel. Time exposures should only be made with a sturdy tripod—you can minimize risk of camera shake by tripping the shutter with the RS-60E3 remote release accessory.

Aperture-priority Mode

Aperture-priority (Av) mode allows you to control the area of perceived sharpness (depth of field) in the photograph. In this mode, you set the desired aperture in 1/2-stop increments using the Main Dial, and the camera automatically selects an appropriate shutter speed between 1/4000 and 30 seconds, depending on lighting conditions. Until you change it, the value shown in the

The vast depth of field evidenced in this photograph was attained by using a 24mm lens set at f/22.

viewfinder and on the LCD panel is the last aperture that was used by the Av mode.

Depth of Field: Only a segment of a three-dimensional object can be truly in focus at the focal plane. Everything on that object that's not in this plane will be depicted not as a sharp dot, but as a blur, called the "circle of least confusion." Because of the focusing tolerance of the human retina, however, we perceive the circles as sharp dots as long as they are smaller than the resolving power of our retina. This means that areas in front of and behind the focus plane appear more or less in focus.

In practice, the area of depth of field increases as the lens aperture is stopped down or the focal length decreases. The amount of depth of field decreases as the lens aperture gets larger, the focal length increases, and the camera-to-subject distance decreases. At the point of critical focus, there is a range of acceptable sharpness. One-third of this range lies in front of the plane of focus, and two-thirds behind it. That range is called the depth of field.

Extent of depth of field: Depth of field usually stretches approximately one-third in front of the plane of focus and two-thirds

A 180mm lens with an aperture of f/4 produced this shot using limited depth of field as a creative tool.

behind it. In the close-up range, depth of field shrinks to about half in front of the focus plane and half behind it. With even closer photographs, the depth of field reduces to about two-thirds in front of and one-third behind the focal plane.

Depth-of-field preview: The depth-of-field preview button allows you to visually check depth of field. The button is located beside the lens mount, below the lens release button. Pressing this button in Program, Shutter-speed Priority, Aperture-priority, Manual Exposure, and Depth-of-field modes causes the lens diaphragm to close to the selected aperture. When looking through the viewfinder, you should be able to determine whether or not the current working aperture provides the desired depth of field.

The precision with which the depth of field can be determined depends on several variables, including the photographer's eyesight and the working aperture. This is because the ground-glass image gets progressively darker as the aperture decreases. While the viewfinder will get darker, the secret to using the depth-of-field preview button is to look at out-of-focus areas to see if they come into focus. For some photographers, the ability to visually evaluate depth of field becomes easier the more they use the depth-of-field preview button.

Aperture Control: In every lens, the diaphragm is a mechanical device that controls the amount of light entering the system. The lens' aperture is a diaphragm opening that is expressed as a ratio of its focal length. A smaller aperture is expressed as a larger aperture number. The aperture number is typically referred to as the aperture.

Because the shutter speed range on the Elan 7/7E is significantly larger than the aperture range, incorrect exposures are usually not an issue in Aperture-priority mode. The camera, however, can select long exposure times that increase the risk of camera shake.

However, if an exposure time of 30 seconds, the logest possible for this camera, flashes in the viewfinder and LCD panel, the speed is too short for the selected aperture. The resulting image will be underexposed. This can be avoided by selecting a larger aperture or by using flash, if the subject is within the flash unit's distance range. The exposure would then be made using the selected aperture and a sync speed of 1/125 second.

If a scene is too bright for the selected aperture and 1/4000 second, the shutter speed display will flash in the viewfinder and LCD panel. An overexposed image will result unless you select a smaller aperture. If that doesn't work, it's time to reach into your camera bag for a neutral density filter.

All camera functions, including exposure modes, AF and film advance modes, manual exposure corrections, automatic exposure bracketing, and the self-timer, are compatible with Aperture-priority mode. In this mode, a basic setup might consist of evaluative metering, one-shot AF, manual focusing point selection, and single-frame film advance.

Because it offers some control over depth of field, Aperture-priority mode is ideal for portraits, landscapes, still lifes, and architectural work. Evaluative metering will deliver correctly exposed images with subjects exhibiting normal to slightly higher contrast. Extreme backlight, or subjects with high contrast, are better served with manual exposure correction; when shooting portraits in front of light or dark backgrounds, partial metering with exposure lock is useful.

Manual Exposure Mode
Manual Exposure (M) may seem a bit antiquated, particularly on the latest-generation autofocus cameras, but it offers discerning photographers total control over the exposure. Since both aperture and shutter speed are selected manually, newcomers to SLR photography can learn about the relationship between aperture and shutter speed by using this mode.

To activate this mode, set M on the Command Dial, opposite the camera's index mark. When you activate M mode, all of the values used last time in this mode appear on the LCD panel and viewfinder. This is true even if the camera has been turned off and on several times in the interim. Starting with these values, you can then enter the desired shutter speed and aperture. Shutter speeds are controlled using the Main Dial, and apertures using the Quick Control Dial.

When a specific shutter speed is set, exposure has to be balanced with your choice of aperture. This balancing act is displayed in the viewfinder and LCD panel using the linear scale that typically displays exposure correction. Under these conditions, when a combination of shutter speed and aperture places the pointer in the zero position, the exposure is considered correct. The exposure range is indicated as over ±2 stops in 1/2-stop increments. If the marker under the –2 or +2 positions flashes, the exposure is more than 2 stops off.

Ability to open up and control the aperture allows creation of a soft background, which helps to emphasize the sharper subjects in the foreground. Photograph by Joe Farace.

Evaluative metering was used in the photo on left with good results. However, the one on the right was manually set at one-half stop less, producing a richer interpretation of this farm scene. Photographs by Joe Farace.

Manual Exposure is considered a program mode, and is compatible with other camera functions, including all exposure modes, AF and film transport modes, and self-timer. In Manual Exposure mode, the depth-of-field preview button is important because it allows you to visually determine what's in focus and what isn't. Unhindered selection of shutter speed and aperture, perhaps combined with manual focus, provides the ideal solution for difficult subjects such as backlit situations, specific over- or underexposures, low-key or high-key shots, extended exposure bracketing, experimental photography, or shooting with dark or special-effects filters.

Using the setting indicated in Manual Exposure mode yields excellent exposure even in bright sunlight.
Photograph by Joe Farace.

A basic setting for Manual Exposure mode could be center-weighted averaging metering, one-shot AF or manual focus, manual focusing point selection, and single-shot film advance.

Depth-of-field Mode

In Depth-of-field (DEP) mode, the desired depth of field can be precisely set by aiming the selected AF focusing point at two separate subjects. You can also use DEP mode to limit the depth of field by selecting the focusing point two times on the same spot.

DEP mode only functions with autofocus—so the AF/MF switch on EF lenses must set to AF—but you can choose between manual, Eye Control (7E), or automatic selection of the focusing point. In Automatic Selection mode, the camera always selects the central focusing point.

Choose the closest point you want in focus by aiming the active focusing point (the one in red) at it and depressing the

This photo is an excellent example of how Depth-of-field mode can be used to advantage. The first AF measurement (dEP1) was taken on the cactus in the foreground, and the second measurement (dEP2) on the obelisk in the background. The final result is sharp and pleasing to the eye.

shutter halfway. The green AF indicator in the viewfinder will light up and dEP1 appears in the data display. Release pressure on the shutter button, then aim the active focusing point at the farthest point of desired focus. Touch the shutter button until the green AF indicator lights and dEP2 appears in the data display. Let go of the shutter button and frame as desired. The actual exposure is made the third time the shutter button is depressed. The camera chooses aperture and focus settings that keep everything between the two selections in focus; it doesn't matter whether you focus on the closest point or the furthest point first (dEP1 or dEP2).

If the desired depth of field cannot be achieved, the aperture number flashes in the displays. The exposure will still be correct, however. If the depth of field cannot be realized using the smallest available aperture, increasing the subject distance or selecting a shorter focal length lens will help. But you won't be able to capture a format-filling image with the same composition, and cropping the image will show the same depth of field as the original.

In DEP mode, exposure metering takes place just before the shot is made, so any exposure metering method can be used. Keep in mind that DEP mode will usually select small apertures, which in turn produces longer exposure times. When using a zoom lens, make sure the zoom position remains constant. If it changes, the camera's calculations will not work.

Mirror Lockup

Custom Function 5-1 activates mirror lockup. To cancel the function, reset Custom Function 5 to zero.

Once mirror lockup is enabled, press the shutter button completely to place the mirror in the up position. The frame is only exposed after the shutter button is pressed a second time. Mirror lockup helps avoid vibrations caused by the action of the mirror. A sturdy tripod is an asset for avoiding blurred images when using mirror lockup. To completely eliminate camera movement, you should use either the RS-603 remote release, the RC-1 wireless controller accessory, or the self-timer.

The lockup can be reset by turning the camera off, but the mirror will flip back down automatically if the exposure is not made within 30 seconds. Mirror lockup is best used in Manual Exposure mode with manual focus, but can also be used in P, Tv, and Av modes.

Multiple Exposures

Up to nine separate exposures can be made on a single frame of flm. Multiple exposures can be created in Program, Aperture-priority, Shutter Priority, Depth-of-field, and Manual Exposure modes.

To activate, press the function button on the camera's back until the arrow in the LCD panel points at the multiple-exposure

To enter multiple exposures: press the function button until the arrow appears opposite the multiple-exposure icon. Enter the desired number (maximum 9) of exposures using the Main Dial.

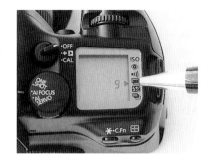

(overlapping frames) icon. Then turn the Main Dial to select the number of exposures you want to make—up to nine. During the exposures, the arrow on the LCD panel flashes and the individual exposures are counted down. The function remains active even if the camera is turned off and back on again; even an interrupted series can be continued. To cancel this function before or during the exposures, select the number one. If the Command Dial is moved to Full Auto or any of the subject programs, the function is canceled. At the beginning or end of the film roll, positioning of individual film frames can be somewhat imprecise, so use this mode toward the middle of the roll.

An example of a simple but effective double exposure.

Making full use of this function requires more planning than merely shooting a series on unrelated frames. For example, it is possible to indicate motion by combining a sharp image with a blurred one, or to capture a movement with a series of stroboscopic flashes.

Metering
One of the most difficult parts of making multiple exposures is metering. In multiple exposures, elements of the image tend to overlap. The intensity of each overlap is determined by the sum of the intensities of the individual exposures. One rule of thumb holds that the exposure time metered for a normal shot should be divided by the number of multiple exposures, but this is only a guideline and is subject to experience and a bit of hand metering. For precise exposure metering, you have to know if and where certain elements of the subject overlap in the shot. In case no subject elements overlap and the unexposed elements are covered in each shot, you can generally meter each exposure individually to arrive at the appropriate aperture. Use the metered aperture with each individual shot.

Things get more complex if parts of the subject overlap or blend into each other. If you simply meter each shot individually in flash or continuous light, these areas will be overexposed. With a 35mm camera like the Elan 7/7E, you need to do a little math:

❏ If a subject is photographed three times on one frame, each individual shot can have only one-third of the total illumination required for correct exposure.

❏ If the three shots were uncorrected, the overlapped subject area would receive 300 percent more light than required. An option is to multiply the film speed by the number of individual exposures, and to perform the exposure metering for the increased film sensitivity. As an example, using ISO 100 film, 3 x 100 ASA = 300 EI.

You can set the film speed manually on the Elan 7/7E by pressing the function button until the arrow points at the ISO setting on the LCD panel, and then rotating the Main Dial until you get the exposure index you want. The Elan 7/7E's display does not set at 300. The closest setting is 320, which in terms of

aperture stops, is 0.2 stop less than an EI of 300. (At 300, the correction would be 1.5 stops, compared to 320, which is 1.7 stops.) Photographers who just want to have fun will experiment with negative film and not worry too much about minor exposure variations.

Correction Factors: The recommended amounts of exposure correction for multiple exposures are:

 With 2 exposures: –1 stop per shot
 With 3 exposures: –1.5 stops per shot
 With 4 exposures: –2 stops per shot
 With 5 exposures: –2.5 stops per shot
 With 6 exposures: –3 stops per shot
 With 7 exposures: –3.5 stops per shot
 With 8 exposures: –4 stops per shot
 With 9 exposures: –4.5 stops per shot

Lenses

The true advantage of a high-quality SLR is the wide variety of interchangeable lenses and accessories that are available. As important as the camera is in photography, it is the lens that has the greatest direct effect on the quality of the picture and makes it possible to convert creative ideas into images. For every area of photographic interest, you can expand your Canon camera system to further your capabilities. As you would expect, Canon offers a vast range of lenses for the Canon EOS 7 and 7E. In this chapter, you will learn all about lenses, including compatibility, features and specifications, and choosing focal lengths.

Canon offers a wide range of lenses from 14mm to 1200mm to create the perfect system.

Lens Components

The bayonet mount is a precision mechanical device that couples the lens to the camera. It ensures that the optical axis is always perfectly horizontal to the film plane.

20mm

24mm

35mm

50mm

Nine shots taken from the same position with different focal lengths. The photographer's shadow in the 20mm and 24mm photos provide a reference for the camera position.

70mm

The diaphragm is a mechanical iris arrangement consisting of multiple crescent-shaped blades that limit the amount of light passing through a lens. The aperture is the hole formed by the diaphragm.

The helicoid is a highly precise rotating cylinder with multiple threads that moves elements and groups of elements in order to obtain focus.

The lens barrel is a hollow cylinder made of metal or plastic in which the lens elements are positioned and centered according to careful calculations.

100mm

135mm

200mm

300mm

Lens Specifications

Focal Length

Focal length, the most important lens specification, is the distance between the image or subject plane and the focal point of the lens. A lens is referred to by its focal length and maximum aperture, which is engraved on each lens. (e.g., 85mm f/1.8 or 28-200mm f/3.5-5.6). Focal length determines a lens' reproduction ratio, extension, and angle of view. The focal length as well as the subject distance determines the reproduction ratio, or how large an object will appear on the film plane. It's important to remember that reproduction ratio is proportional to the focal length. With a constant subject distance, doubling the focal length doubles the reproduction ratio and vice versa. The subject captured by a 50mm lens will be half as large when captured by a 25mm lens and twice as large when using a 100mm lens, assuming the camera-to-subject distance remains constant.

20mm

35mm

50mm

70mm

100mm

200mm

Six shots taken to show the effects of focal length and camera position on the relative size of objects. The camera-to-subject distance increased with the focal length to keep the size of the person consistent in each photo.

Lens Speed

Photographers often refer to a lens as "fast" or "slow." Those with a wide maximum aperture, such as f/1.4 to f/2.8, are considered "fast," because the large opening allows a great deal of light to expose the film in a short time duration. They allow us to use faster shutter speeds than the "slow" lenses that have a small maximum aperture, such as f/5.6.

Apertures are quantified by f/numbers, which represent the ratio between the focal length of the lens and the diameter of the opening. If a lens with a focal length of 90mm has a maximum diaphragm diameter of 45 mm, the aperture ratio is 90:45 or 2:1; hence the aperture is usually expressed as f/2. A small f/number means a wide aperture: the lens is capable of letting more light pass through to the film plane. A 50mm f/1.4 lens, for example, is "faster" than a 50mm f/1.7 by 1/2 stop.

Angle of View
Angle of view is another key lens characteristic. All lenses project an image circle onto the film plane that gets progressively darker and blurry as you get to the edges. The usable image area is the sharpest area of this circle, which must measure at least 43.3mm (the diagonal of the 35mm film frame). A normal lens for 35mm photography is usually rounded to 50 mm. If you use the diagonal of the imaging format as the basis of a triangle, the two equal sides subtended by this line form the angle of view. The angle of view depends on the focal length and image format. A Canon EF 20mm lens has an angle of view of 94°, while a 135mm lens has only 18°. A 50mm lens with an angle of view of about 45° is considered a normal lens in 35mm photography. Lenses with an angle of view of more than about 50° are considered wide-angle. Lenses with an angle of view narrower than 40° are considered to be telephoto.

Lens Aberrations
Imaging errors are sometimes referred to as aberrations and can be divided into chromatic (errors appearing with colored light) and monochromatic (errors appearing with monochromatic light.) Monochromatic aberrations can be divided further into loss of sharpness and scaling errors. The most important optical errors are spherical aberration, asymmetry errors (or coma), astigmatism, and field curvature. Monochromatic errors can be attributed to geometric causes in the paraxial field. Chromatic errors can be attributed to dispersion, or the different refraction indices of the light and is subdivided into longitudinal or lateral aberration.

Correcting Chromatic Aberration
The secondary spectrum is a latitudinal color error that appears

as a color halo in the image, which we see as blur. In order to achieve freedom from color errors, the secondary spectrum has to be corrected so all three colors focus on the same plane. Chromatic aberration increases with focal length and high-quality lenses use specialized glass to correct for it. A lens that brings two colors—typically red and blue—to a common focus point is an achromat, while a lens corrected for all three primary colors is called an apochromat, often shortened to APO. Lenses with ultra-low dispersion (UD) glass elements can be considered to be apochromatic.

Choosing Lenses

Manufacturers often throw in many confusing specifications when describing their lenses. Consider your photographic purpose when you look at a lens. This will help you determine the importance of various lens characteristics.

❏ Minimum focusing distance and maximum magnification ratio are characteristics that are important for close-up and macro photography as well as for full-format portraits and detail shots.

❏ Minimum aperture can be used to calculate the maximum depth of field for a given magnification ratio.

❏ Filter diameter is important for purchasing filters or other screw-on lens attachments for your lens.

Other information such as overall length, maximum diameter or weight can be important for travel, nature, or landscape photography, but are also of interest to photographers who have to carry their equipment for any length of time or to store it in limited space.

Lenses and Perspective

Perspective is the two-dimensional depiction of three-dimensional subjects. In photography, we use perspective to depict not only an object but the entire space encompassed by the lens' angle of view into a two-dimensional picture. The first consideration in transforming an idea into an image is determining the desired perspective, which, in turn, determines camera position

Parallel lines that are on an angle to the image plane converge at a secondary vanishing point.

Parallel lines that are perpendicular to the image plane and run into the depth of the shot converge at the main vanishing point.

and focal length. A realistic, undistorted image is best taken with a 50mm lens or moderate telephoto. The distance depends on the focal length and the subject size, but short distances increase distortion while larger distances tend to make images look more natural. Also, holding the camera so the film plane is parallel to the subject will help prevent distortion.

The laws of perspective affect the appearance of depth in a photograph and two important aspects of these laws—foreshortening and converging lines—can have major impact on an image. When foreshortening is applied, objects close to the

20mm lens at 1 foot (.3 m)

100mm lens at 3.3 feet (1m)

20mm lens at 1 foot (.3 m)

100mm lens at 4.3 feet (1.3m)

20mm lens at 1.3 feet (.4 m)

100mm lens at 8 feet (2.4 m)

Comparison photographs of round and rectangular objects taken with wide-angle and telephoto lenses show how different focal lengths represent perspective. Camera-to-subject distance was adjusted to reproduce object at approximately the same size.

The two photos on page 105 were taken from the same location with a 28-135mm zoom. The upper photo was taken with the lens zoomed to 135mm; the lower one was taken at 28mm. The two photos illustrate the reduction in the angle of view with increasing focal length.

Color is an important element in determining the mood of an image.
Knowing the basics of color theory is helpful.

The photo at left, a doorway of an abandoned farm building, was photo-graphed using the Canon EF 28-90mm USM at a focal length of 50mm. The subject framing changes dramatically when the lens is set at 90mm, as demonstrated above. Photographs by Joe Farace.

Polarizers are essential gear for travel photography. The shot on page 110 was taken without a polarizer and is a bit flat and washed out. In the two shots on page 111, the polarizer enhances the sky, produces more detail in the statues, and increases color saturation.

Both black-and-white photos were taken from the same position using the same focal length (200mm) and display virtually the same perspective. The difference in the photos is the result of emphasizing more sky in the top composition and more foreground in the bottom picture.

camera appear larger while objects further away appear smaller. This effect is especially noticeable at short subject distances and hardly noticeable over longer distances. The effect of foreshortening is most obvious when using wide-angle lenses, particularly if there are sharp objects in the foreground as well as in the background. A small rock, for example, shot at a distance of nine inches (25 cm) with a 20mm lens will look like a huge

A focal length of approximately 135mm represents the point where image compression begins to occur. Notice the tall, narrow effect of this photograph. Photograph by Joe Farace.

boulder in the final image. A frame-filling portrait, shot close up with a wide-angle lens will produce a caricature of that person by creating an exaggerated nose and distorted expression.

The laws of perspective dictate the appearance of converging lines. Parallel lines that are horizontal in the image and vanish into the distance appear to converge at a vanishing point. You can prove this by shooting a straight road or train tracks that run horizontally through the frame. Parallel lines running diagonally through the frame seem to meet at secondary vanishing points. This is the case if two diverging tracks are shot from the point of view of a switch, or two fences coming together are photographed at the juncture.

When shooting a set of railroad tracks, you'll notice the rails running parallel to the image plane also appear parallel in the image. This means that lines parallel to the image plane remain parallel in the image because their vanishing point lies at infinity. This is important for distortion-free images in architecture and copy work. You can use short focal lengths to create interpretive images. When using a short camera-to-subject distance, the vanishing point moves forward and converging lines are steeper. Objects are no longer rendered in natural relationships and anything close to the camera appears oversized while distant objects are diminished in size. Tipping the film plane can increase this unconventional view of things even further.

When selecting a focal length and subject distance, the shape of the subject is also important. In order to capture round and square objects naturally, choose a moderate telephoto and a sufficiently large subject distance. Round objects are then captured as they appear, cylindrical walls are parallel, and openings appear round. The edges of rectangles are practically parallel, converging lines are barely hinted at and cannot be seen by the naked eye. The perspective is natural and you could consider it a true image. If you photograph the same subjects over a short distance using a wide-angle lens, you'll find the cylinders are distorted. At the edges of the image, round openings are distorted into ellipses. Cylindrical walls converge at the bottom and appear conical.

Lens Compatibility

Since the EOS line was launched in 1987, every Canon EF lens with autofocus capability is compatible with every EOS body that's ever been made. The oldest EF 50mm f/1.8 or 35-70mm f/3.5-4.5 lens can be used on a brand new Elan 7/7E, but this compatibility is guaranteed only with lenses and accessories made by Canon. Over the years, there have been a number of improvements and performance additions made to EOS cameras and lenses, but the number of gold lens mount contacts has not changed. This was accomplished by altering the order in which data is transmitted. The CPU (Central Processing Unit) built into EOS bodies and lenses—each lens has one—accommodates any new functions.

Although generally reliable, the CPUs in third-party lenses may not perform every function as well as a lens created by Canon. The only way to know if any third-party lens will fully operate on the EOS Elan 7/7E is to actually try it out, preferably taking a few actual photographs to assure that all functions are working correctly.

EF Interchangeable Lenses

All of Canon's EF lenses ranging from 14mm to 1200mm are available for use with the Canon Elan 7/7E. The properties and uses of individual interchangeable lenses are described by the focal length and angle of view. The differences between 20mm, 21mm and 22mm, for example, are slight and almost impossible to discern with the naked eye. In the telephoto range, differences of up to 20mm, such as between from 180mm to 200mm are difficult to see. In addition, the perspective of an image isn't affected by the use of a zoom or fixed focal length lens, autofocus or manual focus lens when shot from the same position at the same focal length. That's why the next sections examine the characteristics of the interchangeable lenses by focal length range.

Ultra Wide-angle Lenses
The Canon EF lenses in the extreme wide-angle range are EF 14mm f/2.8L USM, EF 20mm f/2.8 USM, EF 17-35mm f/2.8L

USM, EF 20-35mm f/3.5-4.5 USM, and EF 22-55mm f/4-5.6 USM. The EF 15mm f/2.8 is a fisheye and is covered later with the special lenses.

Canon EF 17–35mm f/2.8 L USM lens.

The extensive depth of field and sweeping angle of view characteristic of extreme wide-angle lenses give images the appearance of depth.

Distortion is greater at the edges of the frame and in the corners than in the center of the image.

Images made with an extreme wide-angle lens can have a powerful effect on the viewer. With their large angles of view ranging between 114° and 94°, lenses with focal lengths between 14mm and 20mm show an unusual view of the world. They present a view that differs from our conventional angle of view, which opens many creative possibilities. Extreme wide angles create a dramatic sense of depth. Being close to the main subject makes it the dominant object in the frame, while the background retreats into the distance. Composition is of critical importance in images with a monumental foreground, vanishing background, and expansive horizon. The main subject should be placed carefully in the frame.

The extremely wide angle of view captures a large area of the subject. The range of details captured on film can become distracting, but sometimes this isn't noticed until looking at the final image. To avoid disappointment, carefully compose the image

117

and check the entire frame in the viewfinder and look in the corners for compositional surprises.

Even with the aperture wide open, ultra wide-angle lenses have lots of depth of field. This makes it possible to capture both foreground and background in sharp focus. This depth of field and emphasized converging lines gives an image a feeling of space or great expanse. Photojournalists often favor these lenses because they can produce the feeling that the viewer is actively participating in the scene. Snapshots made with extreme wide-angle lenses are more apt to be sharp because of the extended depth of field and also the danger of camera shake at such short focal lengths is small.

Ultra wide-angle lenses are excellent for architectural work. The wide angle of view allows you to shoot multi-storied buildings from a relatively short distance while holding the camera parallel to avoid converging lines. Attaching a level to the flash shoe makes it easy to orient the camera parallel to the subject plane. The fact that there's generally too much foreground in the lower half of the image, particularly when shooting from ground level, is not always a disadvantage. The street or lawn can be used as part of the image composition. If the foreground is distracting or uninteresting, some judicious cropping can help. Then again, converging lines, even in architectural photography, are not always incorrect. Used carefully, they can lend a dynamic feel to architectural shots. Ultra wide-angle lens is also a favorite tool for shooting in small rooms. A hot-shoe flash usually cannot illuminate an entire room evenly though. Try bouncing the flash off the ceiling instead.

The short minimum focus distance of ten inches (25 cm) offered by the EF 14mm f/2.8 and 20mm f/2.8 allows even small subjects to dominate the frame. Photographing toy models using exaggerated wide-angle characteristics is an excellent example of this technique. When photographed at close range a small clump of earth can appear as big as a mountain, a puddle can look like a lake, and a pebble turns into a boulder.

When photographing landscapes with an extreme wide angle, exposure metering takes on greater importance than usual. Thanks to the huge angle of view, the sky covers a significant portion of the frame. A big difference in contrast between the sky and the landscape can confuse even the matrix metering system

so that the landscape in the foreground ends up being underexposed. Depending on the expanse of the sky and the subject contrast, a correction of plus one to plus two stops could be necessary.

Because of the extreme angle of view, an effective lens shade is not possible in this focal length range. The small, built-in hood on most ultra wides protects the large, convex front element from physical damage more than it prevents flare. Providing additional shading with a hand or another object isn't a good idea because you might end up with a hand in the frame.

Natural vignetting is a characteristic of some extreme wide-angle lenses that results in light fall-off toward an image's edges. Artificial vignetting is caused by interference in the light path caused using incorrectly sized lens hoods, thick or multiple filters, and other objects encroaching on the angle of view. The darkened corners of the frame caused by both kinds of vignetting looks identical. This affects not only extreme wide-angle lenses, but also lenses with large maximum apertures and zoom lenses. Vignetting is particularly obvious with bright, even-toned subjects, such as landscapes with large expanses of sky or light colored walls. With most lenses, stopping down will reduce natural vignetting and the effect is usually not noticeable at f/5.6 and higher.

Moderate Wide-angle Lenses
Wide-angle lenses between 24mm and 28mm are popular among photographers and bridge the gap between extreme and classic

The Canon EF 24mm f/1.4 L USM lens.

A 24mm lens is ideal for all encompassing shots that maintain a natural appearance even though the converging lines are emphasized.

wide-angle lenses. This moderate position is the basis for the universality of this focal length range.

The relatively wide angles of view from 84° to 75° give images true wide angle characteristics, but without overly emphasizing perspective. The resulting images taken with these lenses are well balanced; despite the fact their angles of view are approximately one and a half times to twice as large as that of our eyes. If you tilt the camera or choose a low camera angle, the perspective will be exaggerated. A "worm's eye view" can emphasize perspective and exaggerate relative sizes. Unconventional camera positions can increase an image's effectiveness, but keep in mind that you run the risk of moving into the banal.

The extensive depth of field and the relatively fast speed of lenses in this class make them ideal for photojournalism. Landscapes, cityscapes, snapshots, or environmental portraits are other

The slightly wider angle of view of the 35mm lens makes it useful for ⇨ taking photographs if space is a little tight.

applications where these lenses show their strengths. Lenses in this category, particularly the 24mm, are the first choice for journalists shooting under available light in small, interior rooms. The large depth of field and the fast speed make for dynamic images conveying closeness to the scene because all of the main subject's surroundings are included in the frame.

Wide-angle Lenses

For decades 35mm was considered *the* wide-angle lens, but technical advances have enabled the design and production of well-corrected lenses with increasing angles of view. The extreme wide-angle's greatest success was changing the way we look at the world; the result was that images made with the 35mm no longer seemed to exhibit wide-angle characteristics. This doesn't mean the lenses have gone out of favor, however. The 35mm focal length has become more of a standard lens, especially among photojournalists.

With an angle of view of 63°, a 35mm lens allows you to capture significantly more of a subject than a 50mm lens. It doesn't exaggerate perspective like shorter focal lengths though. The depth of field is greater than a 50mm and there is less risk of camera shake. Snapshots, photojournalism, landscape photographs, group shots, environmental portraits, or architectural details are the domain of the 35mm. Canon offers two 35mm prime lenses, the f/1.4 and f/2. Lenses with a fast aperture of f/1.4 are ideal for available-light photography, but lenses with a speed of f/2 are more compact and lighter weight than the f/1.4.

Standard Lenses

The 35mm format has a diagonal of 43.3mm, but since 50mm lenses are easier to design and less expensive to produce, they were selected as the standard lens. The perspective displayed by this lens corresponds to our visual impressions of the world. Their 46° angle of view also corresponds to the angle that our eyes see when at rest. Eye and head movement as well as the imaging processor in our brain captures a larger angle, meaning the 50mm may seem a bit narrower. The use of interchangeable and zoom lenses have led to the perception that images made with a 50mm lens are boring, but Henri Cartier-Bresson, who shot many classic images with a normal lens, has proven this is not true.

Standard focal length lenses are excellent for documentation because their angle of view approximates human vision.

In addition to the 50mm (46°angle of view), normal lenses include anything up to 60mm (39°) and are covered by a variety of zoom lenses. One interesting entry is Canon's exceptionally fast lens—the EF 50mm f/1 L USM lens.

Canon EF 50mm f/1 L USM lens.

The focal length range of 50 to 60mm is ideal for just about any application: journalism, snapshots, travel photography, still lifes with larger subjects, environmental portraits, children, or group shots. Normal lenses with speeds up to f/1.4 are compact, light and economical. Fast lenses with maximum apertures of f/1.4 or even f/1 are ideal for available light photography. The Canon EF 50mm f/2.5 macro is not only corrected for the close-up range, but also for infinity. Canon offers the fast EF 50mm f/1 L USM, EF 50mm f/1.4 USM, EF 50mm f/1.8 II, and the EF 50mm f/2.5 macro in this range.

Moderate Telephoto Lenses

Moderate telephoto lenses in the 70 to 135mm range are easy to handle and versatile in their applications. The relatively narrow

Canon EF 70–200mm f/2.8 L USM lens.

Moderate telephoto lenses are very popular for portraiture. They compress rather than exaggerate distance, which is more flattering.

angle of view makes it easier to eliminate unnecessary details and be more creative with what's left. The limited depth of field at relatively large apertures allows the main subject to be set off against a blurred background. Frame-filling shots taken from longer distances are also possible, making them popular for travel, journalism, fashion, and snapshots. There is practically no distortion in telephoto shots made in this focal length range. All these characteristics make lenses in the 85mm to 100mm range ideal for portrait photography.

Another positive characteristic of moderate telephotos is the compression of distance, which doesn't reach the level of longer focal lengths and still appears natural. Lenses in this category are relatively easy to design, meaning they exhibit amazing image quality making them ideal lenses for detail shots, still lifes, landscape photography, and architectural photography—if you want to shoot smaller buildings over larger distances without converging lines or foreground. Lenses in the moderate telephoto range are relatively compact, usually are fast, and suitable for handheld photography.

The Canon EF 28–200mm f/3.5–5.6 lens is a compact zoom lens that covers a large focal-length range.

The angle of view is 34° at 70mm, 28°30' at 85mm, and 18° at 135mm. The difference between one end of the range and the other is more pronounced than in other groups. Most of the prime lenses in this range are offered as fast lenses with a maximum aperture of f/1.4, f/1.8, or f/2. The bright and contrasty viewfinder image and limited depth of field at maximum aperture make it easier for the autofocus system as well as manual focusing under poor lighting conditions. The fast lenses in this group are ideal for portraits, journalism, and theater photography, particularly in available light.

The Canon EF 100mm f/2.8 macro is designed as a macro lens, but you can use it over the entire range to infinity. The

Canon EF 135mm f/2 L USM lens.

longer focusing range necessitates longer barrel extensions that, in turn, results in longer focusing throws, even with the focus limit switch, making the lens slow.

The 135mm with its 18-degree angle of view exhibits more spatial compression than other lenses in this group. Hand-held shots should only be made with shutter speeds of 1/250s or 1/500s to minimize the danger of camera shake. The 135mm can be used for portraits, architecture, and snapshots, as well as photographing plants and animals. Compact design and light-weight make it a popular travel lens.

Standard Telephoto Lenses

Lenses with focal lengths between 180 and 300mm are generally categorized as standard telephoto lenses. They show spatial compression, reduced angle of view, and limited depth of field. You can easily use these lenses to fill the frame with even a small subject over moderate distances. These focal lengths are not sufficient to bridge larger distances, and while they're great to photograph animals in the zoo, they're not the best choice in the wild.

Canon EF 200mm f/1.8 L USM lens.

Canon EF 300mm f/4 L USM lens.

The 180mm has 3.6X magnification and the 300mm has 6X magnification compared to a 50mm lens.

The lenses in the standard telephoto range are suitable for landscape photography and you can use them to fill a frame with a mountain or to extract certain characteristics of a landscape. In architectural photography, distant details, such as a spire, or rows of houses can be compressed into a single frame. Fast telephoto lenses—those with a large maximum aperture—are wonderful for available-light photography, theater and concert photography, wildlife, and landscapes.

The angles of view in this focal length range are as follows: a 180mm lens offers 13°40', a 200mm is 12°, and a 300mm is 8°15'. The 180mm and 200mm lenses, as well as some of the zooms in this category, are quite compact making it possible to

If you don't want to distract your subject or make them feel self-conscious, use a telephoto lens to take head-and-shoulders shots from a distance.

handhold them at shutter speeds of 1/500 second or faster. With a 300mm lens, you shouldn't handhold at shutter speeds slower than 1/1000 second and even this fast shutter speed doesn't guarantee a shake-free image. You are much better off shooting from a stable tripod or from a monopod if mobility is important, such as with sports or wildlife photography. The heavier lenses in this category are equipped with a tripod mount that rotates for either horizontal or vertical shooting. If your lens is equipped with a tripod mount, be sure to use it and not the tripod mount on the camera body. Otherwise, the camera's bayonet mount can be damaged due to the weight of the lens.

Super Telephoto Lenses
The most common focal lengths in the super telephoto category are 400mm (angle of view 6°10'), 500mm (5°), and 600mm (4°10'). Canon also makes a 1200mm lens. The major character-

Telephoto lenses aren't just for distant subjects. The 300mm f/4 lens can focus down to approximately 5 feet (1.5 m) to fill the frame with a small detail.

istic of long lenses is image magnification. You can fill the frame with a small subject even from a great distance, making these lenses perfect for shooting wildlife and sports. The shallow depth of field and compressed perspective of super telephotos are popular effects for fashion and advertising photography. Canon's super telephotos offer the ability to set the lens at a predetermined focus distance; a feature typically used by sports photographers. Focus can be preset on a point, such as the goal. Then you can follow the action anywhere on the field and quickly return focus to the preset point when the action returns to the goal.

With their narrow angle of view and shallow depth of field, long lenses are useful for isolating a subject. This very tightly framed shot was taken in a zoo with a 400mm lens.

Super telephotos should always be used on a camera support. Your best choice is shooting from a professional tripod with mirror lock-up, but telephotos up to 600mm can work on a monopod as well. A rotating tripod collar on the lens makes it easy to switch from horizontal to vertical shots. Remember to always mount the lens, not the camera to the tripod because, the camera's lens mount cannot support the weight of the lens.

Even when shooting from a tripod, you should select fast shutter speeds. Telephoto lenses don't just magnify your subject. Camera shake due to a gust of wind or even mirror vibration will be magnified, which can affect image sharpness. Most telephoto lenses come with a removable lens hood. This not only prevents flare but also protects the front element from physical damage and should always be attached.

Image-stabilization technology makes it possible to take sharp photos while handholding a 500mm lens.

Special Lenses

The Canon lens palette includes a few special lenses that possess unique characteristics and perform specific functions. These special lenses can be divided into lenses for technical or creative applications. Examples of the first type include image-stabilization lenses, macro lenses, and tilt-shift lenses. Because of their optical-physical characteristics, teleconverters aren't really lenses, but they are instruments that can handle assignments that conventional lenses cannot. The second category of special lenses includes optics with unusual characteristics such as fish-eyes, soft focus, and catadioptric (mirror) lenses.

Image-stabilization Lenses

Canon was the first manufacturer to use image-stabilization (IS) technology in interchangeable lenses. When the IS function is activated, gyro-sensors—one for vertical and one for horizontal movement—are activated. They determine the angle and speed of the camera movement. The data is transmitted to a 16-bit micro-

The lighting was dim and the photographer couldn't set up a tripod in this museum. Using image stabilization allowed the photographer to handhold the camera at a slower shutter speed. In the photo taken without the image stabilizer, the photographer had to set a faster shutter speed and the image is slightly underexposed.

processor built into the lens and then converted into control signals for the image stabilizer. The stabilized lens group is moved counter to the camera movement, so the lens can be focused on the subject.

Canon states that image stabilization allows you to handhold the lens at shutter speeds that are two stops slower than the inverse of the focal length normally indicates. That means with a 300mm lens you should be able to hold a shutter speed of 1/60 second instead of the usual 1/250 or 1/300 second. With a 300mm focal length, the image stabilizer works best at shutter speeds between 1/125 and 1/8 second. At shutter speeds faster than 1/1000 second, any effect is hardly noticeable. At shutter speeds slower than 1/8 second, the stabilizer will have some effect, but the image may or may not be acceptably sharp.

Image-stabilization lenses open many photographic possibilities. There are situations in churches or museums where you're not allowed to use flash or a tripod, or when the flash range isn't sufficient to illuminate your subject. An IS lens allows you to

stop down to achieve the desired depth of field even when no tripod is handy.

The only disadvantages of IS technology are slightly higher power consumption and, because the image-stabilization process takes about one second, slightly slower working speeds. These minor disadvantages pale in comparison to the advantages. Canon's IS lenses are extremely fast and quiet when the image stabilizer is activated. Their weight of between 1.2 and 11.8 pounds, depending on the lens, makes them comfortable to hold. Image quality is excellent; and hand-held shots are tack-sharp. Shutter speeds should be matched to the speed and direction of the movement in order to stop action. As a precaution, you should turn the image stabilizer off when transporting the lens. This locks the stabilizing unit and protects it from impact.

Macro Lenses

Unlike zoom lenses that have macro settings, true macro lenses produce magnification ratios of 1:1 or 1:2. Canon offers four prime macro lenses: The EF 50mm f/2.5 compact macro, EF 100mm f/2.8 USM macro, EF 180mm f/3.5 L USM macro and MP-E 65mm f/2.8 macro. The 100mm and 180mm macros can focus at a magnification ratio of 1:1 without additional accessories.

Macro photography presents a fascinating way to look at everyday objects. The gears in this watch are reproduced using a 5:1 ratio.

The 50mm attains a magnification ratio of 1:2 without accessories and achieves life-size with its EF converter but accessories such as lens reversing rings and bellows make reproduction ratios of up to 10:1 possible.

The EF 50mm f/2.5 compact macro is the smallest and lightest of the three, which makes it useful for travel photography. Its primary disadvantage is a short close-focusing distance of 9-inches (23cm) at a magnification ratio of 1:2. The minimum subject distance is measured to the film plane, so the distance between the front of the lens and the subject is shorter and can make subject illumination a problem. If you aren't careful, the camera's shadow can be visible in the shot.

With a working distance of 20 inches (48 cm), the longer 180mm lens is ideal for small animal photography, but because the lens extension reduces the amount of light passing through it, there is a danger of camera shake. The EF 100mm f/2.8 macro lies between these two lenses and is an ideal compromise for many photographers. Its minimum focusing distance of 12 inches (31cm) at 1:1 is large enough and light loss is lower than the other lenses, producing shorter exposure times as well as reducing focal length-related camera movement.

The 180mm macro lens has a working distance of 20 inches; perfect for when the photographer can't get too close a subject, such as this archeological artifact.

The close-up range for macro photography covers magnification ratios from 1:10 to 10:1, which is far beyond most conventional lenses. Traditional lenses are optimized for focus at infinity,

not for a close-up range. This means such lenses have an extended focus range but are not optically true up close. Macro lenses, on the other hand, are specially corrected for the close-focus range and can also be used at infinity.

Tilt-shift Lenses
Tilt-shift lenses are so called because their optical axis can be tilted and shifted using precision mechanical components. Because of their tilt and shift capabilities, the photographer has greater control over focus and perspective. These lenses make it possible to use a 35mm camera to achieve effects normally only possible with large-format cameras. Lenses in this series include the Canon TS-E 24mm f/3.5 L, TS-E 45mm f/2.8, and TS-E 90mm f/2.8, which are ideal for documentary, architectural, and creative applications.

Canon currently offers a 24mm, a 45mm, and a 90mm tilt-shift lens.

All of these lenses can be shifted by a maximum of plus or minus 11mm and tilted to a maximum of 8°. Both tilt and shift controls can be engaged simultaneously using a knob that indicates the amount of the displacement. Opposite each knob are sets of screws that adjust the friction and allow the lens to lock in the desired position. The lenses can be rotated 90° to the left or right and locked every 30°. There are click stops at 0, +/–30°, +/–60°, and +/–90°.

Rather than tipping the camera to include the entire building in the frame, the photographer can hold the camera parallel to the subject and use the shift adjustment on a T-S lens. This prevents distortion and converging lines.

Tilt-shift lenses are the only option in small-format photography to control perspective without changing camera position. Tilting the camera so that the film plane is no longer parallel to the subject plane causes converging lines, which can only be prevented when the film plane is parallel to the subject plane. T-S lenses are used in architectural photography to prevent such convergence. The optical axis can be displaced be shifting the lens so sections of the image that lie outside the angle of view of a conventional lens of the same focal length appear in the film frame. Depending on the subject distance, shifts of a few millimeters can be sufficient to move the image area by several yards or meters. Any change is visible in the viewfinder. When making a shift adjustment, careful camera alignment is crucial and an accessory spirit level can be helpful.

The lens' tilt adjustment lets you to change the location of the plane of focus to isolate or emphasize a subject by using selective focus. A corresponding tilt of the lens lets you place the out-of-focus region anywhere you wish. You can use this technique to suppress unwanted image details or emphasize sharp image areas. The appearance of sharp focus in the image can be increased or decreased, but contrary to popular belief, the depth of field is not increased or decreased. Modifying the location of

the plane of focus has nothing to do with this. The aperture should be selected so the extension of depth of field does not capture any unwanted details that would affect the desired focus/out-of-focus effect.

The Elan 7/7E's TTL exposure control system can be used with any T-S lens and aperture control as well as exposure-related data is transmitted between lens and camera via the standard EOS gold contacts. An exposure correction of plus one-half or one full stop might be necessary to compensate for any vignetting caused by extreme lens displacement.

In normal settings, TS lenses offer good sharpness and contrast at maximum aperture. Stopping down two stops increases performance, and it's a good idea to use a maximum of f/8 with moderate displacements and f/11 with larger displacements.

The TS 24mm and 45mm lenses have floating elements to improve their image quality in the close-up range, and both lenses are equipped with internal focusing. But since they don't have autofocus motors, all TS lenses must be manually focused. Because the TS 90mm can focus at a magnification ratio of 1:3.4, the lens extension had to be a little longer, which makes internal focusing impossible.

Curvilinear distortion is characteristic of the 15mm fish-eye lens.

Fish-eye Lenses

A fish-eye lens has a short focal length, an exceptionally wide angle of view, and displays extreme barrel distortion. Straight lines running through the center of the frame are imaged straight, but vertical and horizontal lines that don't pass through the center of the frame are exaggerated. The farther lines are away from the center, the greater the distortion. In photographs using fish-eyes, flat surfaces, such as a walls, are curved and the rules of central

perspective no longer hold true. Some of the terms used to describe fish-eye lenses include spherical, equidistant, and orthographic projection, as well as spherical perspective.

The current Canon EF line includes the EF 15mm f/2.8, whose 180° angle of view covers the entire 35mm film format. Despite distortion, the 180° diagonal view gives images panoramic characteristics. The large angle of view covers a variety of image areas with different contrasts that might confuse the Elan 7/7E's exposure meter. Depending on the subject, manual exposure corrections of plus one or two stops might be necessary, or may decide to bracket.

Teleconverters

Teleconverters, also called extenders, are used with a lens to increase its focal length. The good news is that teleconverters extend the focal length of the lens they're attached to; the bad news is they reduce the maximum aperture. For photographers who seldom use certain focal lengths, teleconverters can be a good compromise. If a teleconverter can replace an extra lens or two, you can keep your travel kit small. Extenders are not only useful for telephoto shots, but can be used for close-up applications because the minimum focus distance of the lens remains the same.

Teleconverters are really lenses that have a negative focal length. Canon offers two high-quality optical EF teleconverters designed for L-series telephoto lenses 135mm and longer, as well as for several EF-series zoom lenses. The EF 1.4X II has an extension factor of 1.4 and the EF 2X II provides a two times extension factor. With a 2X converter, the EF 300mm f/2.8 becomes a 600mm lens with a maximum aperture of f/5.6. Because of the darker viewfinder image caused by the reduced aperture, focus can be difficult to achieve in low light. Fortunately, the Elan 7/7E's central focusing point is highly sensitive and will focus even in poor illumination.

Since teleconverters are systems placed into the optical path of the lens, they almost always affect sharpness and contrast. How much contrast and sharpness is lost depends not only on the teleconverter's degree of correction, but whether the extender was designed for use with the lens it's attached to. You'll see the greatest degree of quality loss with inexpensive teleconverters that

can be connected to almost any lens. The loss is minimized using extenders designed for a specific lens, or at least a certain focal length range and lens construction.

Because extenders have a magnifying effect, not only is the focal length magnified, so are its optical errors. Latitudinal errors such as coma and chromatic aberrations are magnified by the factor of focal length extension. Longitudinal errors, such as field curvature or focal distance deviation, increase by the square of the focal length extension. When a lens that has a field curvature of 0.03mm for an axial point, compared to the center of the frame, is combined with a 2X teleconverter, the field curvature increases by the square of the focal length extension. In this example, the deviation of the image plane from the

The 2X teleconverter doubles the effective focal length of a lens allowing you to fill the frame with distant details.

film plane will increase to 0.12mm. The loss of quality primarily affects the edges of the frame rather than the center. Stopping down two stops increases overall optical quality, but there's always the danger of camera shake as well, as correspondingly longer exposure times.

Soft-focus Lenses

Soft-focus lenses are specialized lenses where spherical aberration is deliberately not fully corrected. True soft-focus lenses produce a sharp center image area that's overlaid with softness. This overlay is the main difference between images made using soft-focus lenses and soft-focus filters. The Canon EF 135mm f/2.8 lets you control the amount of softness using a ring on the lens. When using a soft-focus lens for its soft-focus effect, don't stop down past f/5.6, or the spherical aberration will be reduced. The soft-focus effect is popular for portraits, landscapes, and still lifes.

Flash Photography

Electronic Flash

Photography with electronic flash is very simple with the Canon EOS Elan 7/7E camera, Canon's Evaluative Through the Lens (E-TTL) flash metering system, and the EX series Canon flash units. Even the most difficult applications of electronic flash become child's play when this system is used correctly. There are still some photographers of the "old school" who refuse to use electronic flash because they believe pictures taken with it look unnatural. These photographers are missing a lot—particularly the advanced fill flash made possible by the E-TTL system, which measures both ambient light and flash and sets the proportion between the two for a natural look. Photos taken in darkness, fill-flash photos, photos with backlighting—all can be taken with this system to produce excellent and natural-looking results. But to use this system properly, you must know which exposure and operational modes to use for which situations, such as altering the shutter speed or the aperture setting to change the picture's design and appearance.

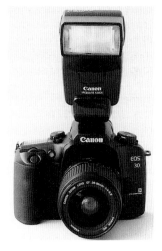

The Canon Speedlite 420EX was introduced at the same time as the camera and is ideally suited to the EOS 7/7E's functions.

Flash Exposure Metering

The E-TTL flash system on the Canon EOS Elan 7/7E, which is designed to balance light from the flash with existing light, is an extremely refined flash measuring system. It works by measuring a preflash, which is fired when the shutter button is pressed, before the camera's mirror goes up. Light is measured by the camera's evaluative metering system described in the chapter on metering modes, but for flash, the weighting of the metering areas is different. For flash, the camera weighs the active AF sensor area as the main metering area, ignoring sensors in other areas; only the metering information from this area is used for the electronic flash measurement. For this reason, very bright or very dark backgrounds will not adversely affect the flash metering, because it will always be based on the main subject. Computation of the metering values is rapid, and results in photographs in which both the foreground and background are properly exposed.

Depending on the subject, the light from the flash is graduated in very fine increments and proportioned so that the look of natural light is not lost. Because ambient light is also analyzed by evaluative metering—and weighted on the AF sensor—a very natural look can be produced in which the flash serves simply to brighten up the shaded areas.

If the E-TTL system flash is used on the EOS Elan 7/7E with the camera set in a different metering mode than evaluative metering, the ambient exposure is measured by the metering system using that mode: centerweighted average, partial, or spot metering. The flash is measured and adjusted by evaluative flash metering and weighted toward the active AF sensor. When using the older Canon EZ series flash units with the Canon EOS Elan 7/7E, A-TTL (Advanced Through the Lens) flash metering is used, which includes ambient metering but without a preflash for flash metering. A-TTL produces excellent results in most applications, but fill flash will not be as finely tuned as with E-TTL. With other flash units, in most cases only simple TTL, without measurement of ambient light, is possible. In these situations, the light from the electronic flash is measured by a separate flash metering cell, which is divided into three areas. This cell measures flash only, not ambient light, and works with the EOS Elan 7/7E's computer to simply shut off the flash tube when a proper amount of light has reached the subject.

The E-TTL flash system is at its most versatile with the new Canon Speedlite 550EX or the 420EX, which was specially designed for the EOS Elan 7/7E. However, E-TTL functions with all EX series flash units including the 380EX and 220EX, in addition to the 550EX and 420EX. Along with the 550EX, the photographer has available cordless remote E-TTL with multiple 550EX flash units mounted off-camera, a totally new system.

EX-Series Flash Functions

The EX series of flash units for the EOS Elan 7/7E offers a wide variety of flash functions activated by buttons on the back panel of the flash units; some functions can also be controlled by settings on the camera.

The E-TTL automatic flash function is the default mode on the EOS Elan 7/7E and the flash, and can be used effectively in all exposure modes. E-TTL uses autofocus-coupled evaluative metering with balanced fill flash, which produces the ideal mix of flash and ambient exposure in most situations.

In Program, Aperture-priority, Shutter-speed Priority and Manual Exposure modes, the flash has to be pulled up manually using the small handles.

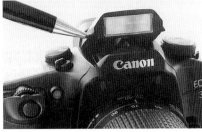

High-speed-flash sync (FP) allows the use of fill flash in situations that would previously have been impossible. Because this mode can be used at shutter speeds between 1/250 and 1/4000 second, it is possible to use it outdoors with a wide aperture, such as f/1.4, to produce a blurred background behind the main subject.

With slow-speed synchronization, which works all the way down to 30 seconds and Bulb setting, it is possible to expose the main subject and background correctly even in very dim light. This would be useful when posing someone in front of a window overlooking a city scene. Such a long exposure allows the image of the city to be rendered instead of a black window

With electronic flash exposure lock (FEL), it is possible to lock the output of the flash to a preselected value. In this case, the flash exposure corresponds to the value obtained at the active AF sensor area.

Flash exposure compensation can be input manually within the range of plus or minus two stops on the camera, or plus or minus three stops using some EX fash unitss. Thus, you can intentionally reduce or increase the output of the flash to produce certain effects without losing automatic function.

Electronic exposure bracketing (FEB) is available at this time only with the Speedlite 550EX and the MR-14EX and does the same thing with electronic flash that AEB mode does with ambient light.

Cordless E-TTL flash control combines the precision of E-TTL exposure with the convenience of off-camera and multiple-flash photography. It is available with flash units such as Canon Speedlite 420EX, 550EX, and MR-14EX.

Flash Displays

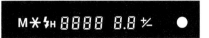

Flash status, high-speed synchronization, and manual flash exposure correction are displayed in the viewfinder. When using flash exposure lock, FEL appears briefly in place of the shutter speed.

Simultaneous display of all data monitor symbols on the Speedlite 550EX.

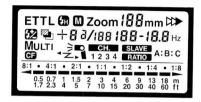

The displays on the back of the flash units give information such as flash function mode and flash distance range. Inside the viewfinder of the EOS Elan 7/7E is a flash bolt symbol, which lights to indicate that the flash unit has fully recycled and is ready to fire. When high-speed-flash sync is being used, [H] appears next to this indicator to advise that this special mode is in use.

Guide Number

Guide number is a method of quantifying the power output of a flash unit. Guide numbers can be used to calculate exposure settings for a given distance, but with more modern methods, such as TTL flash, GN equations are no longer widely used. The flash guide number is calculated by the equation:

Subject distance x aperture = guide number

Guide numbers are expressed in feet or meters for a given ISO film speed. For comparison purposes, they are typically based on ISO 100 film. The guide number also depends on the illumination angle of the flash unit's reflector. The flash's manufacturer usually publishes this value, which can be used in the above equation to calculate other values:

Working aperture = guide number / flash distance
Flash distance = guide number / working aperture

Flash Synchronization

The Canon Elan 7/7E is equipped with an electromagnetically controlled, vertical focal plane shutter. A focal plane shutter

146

consists of two curtains. The first uncovers the image to begin the exposure, and the second curtain follows it, ending the exposure. Both travel at the same rate of speed. Thus, shutter speed is determined by the length of time between the movements of the two curtains.

At fast exposure times, the entire image area is not exposed at the same time. The second curtain closely follows the first and the image is exposed by a slit moving across the film. The slit is generally narrower than the film window and it successively exposes the film frame. If flash is used with short exposure times, only that part of the film that is behind the slit will be exposed. At a slower shutter speeds, the slit becomes wider until the entire frame is exposed for a certain time before the second curtain closes.

With the Elan 7/7E, the fastest speed at which the entire frame is exposed, or the flash sync speed, is 1/125 second. Slower exposure times are synchronized because the focal plane shutter exposes the entire frame at the same time.

When the built-in flash or a compatible accessory unit is turned on, the camera automatically selects the proper flash sync speed in normal sync mode. In Focal Plane mode, the Speedlite 420EX and other EX system flashes can handle shutter speeds up to 1/4000 second.

Summary of Flash Functions

The Elan 7/7E's built-in flash offers TTL flash control in all modes, except Landscape, Sports, and Depth-of-Field (DEP) modes. Its red-eye reduction function can be manually turned on. When used in conjunction with EX-series system flashes, the Elan 7/7E offers additional flash functions depending on what mode is currently set. These functions can be activated on the camera or on the EX flash:

❏ E-TTL flash mode.
❏ High-speed flash synchronization (FP), a feature of EX-series flashes, allows any shutter speed between 1/80 and 1/4000 second to be synchronized with flash.
❏ Shutter speeds slower than 1/125 second and up to 30 seconds, and Bulb, can be used with the Speedlite and the built-

in flash, making it possible to correctly expose both the main subject in the foreground and a darker background.

❏ Flash exposure lock (FEL) enables the flash exposure to be calibrated specifically for certain subject details and locked. Pressing the exposure lock (*) button fires a test flash and stores the results.

❏ Flash exposure compensation can be selected manually over a range of plus or minus two stops on the camera or plus or minus three stops using some EX flashes. This feature lets you manually adjust the flash exposure without losing the automatic function.

❏ Flash exposure bracketing (FEB) is only possible with the Speedlite 550EX and MR-14EX and has the same functionality as the AEB function with ambient light.

❏ Wireless E-TTL flash control combines the precision of E-TTL flash control with the advantages of lighting with multiple EX flash units, such as the 420EX, 550EX, and MR-14EX.

Bounce Flash
Direct flash can often produce a hard-edged look with deep shadows behind the subject, which are not always flattering. Bounce flash can be a solution to these problems. When using a flash that has a tilting head, light can be bounced off a wall or ceiling and reflected onto the subject. This produces even, soft and shadowless illumination. The wall or ceiling should be white or neutral gray to prevent unwanted color shifts in the final image. Canon system flashes used this way retain E-TTL, A-TTL, or TTL functionality.

Setting for the red-eye reduction function.

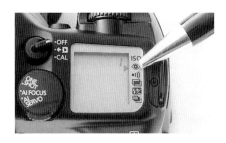

The Built-in Flash

The Elan 7/7E is equipped with a built-in, flip-up flash that has a guide number of 43 with ISO 100 film and illuminates the angle of view of a 28mm lens. Recycle time is two seconds—a flash icon in the lower left-hand corner of the viewfinder indicates "flash ready" status.

In low light and in Full Auto, Portrait, Macro, and Night scene modes, the flash automatically pops up when needed. In Program, Shutter-speed Priority, Aperture-priority, or Manual Exposure modes, the flash must be manually activated. The flash always fires when it's flipped up. When you don't need it, simply push the flash down until it locks in place.

The built-in flash's range is sufficient for most portraits or candid shots. You can also use it to illuminate statues in churches or museums as well as small still lifes. The flash is especially useful for macro photography. If the built-in flash is too weak for certain applications, you can use higher-speed film or one of the more powerful EX system accessory flashes. It's not possible to use the built-in flash simultaneously with an accessory flash.

Red-eye Reduction

In dim light, the pupils in the eyes of people and animals tend to open wide allowing the light from an electronic flash to reflect off the retina, which creates an unpleasant effect called "red eye." The small differential between the optical and flash axis heightens this effect. You've probably seen this before and maybe it has ruined one or two of your photographs. While digital-imaging software can correct this problem, it is usually better to "get it right on the film."

When photographing people, the Canon Elan 7/7E's red-eye reduction capability can be used in any flash mode. To activate this function, keep pressing the function button until the arrow lines up with the eye icon on the LCD panel. To turn the function on, enter 1 using the Main Dial. To turn the function off, select 0. Setting the red-eye reduction function can be done at any time but is only in effect if the built-in flash is flipped up or the accessory flash is turned on. The red-eye reduction feature starts working as soon as you touch the shutter release, causing a small light next the Elan 7/7E's handgrip to shine for 1.5 seconds. A countdown bar on the LCD panel, as well as in the viewfinder,

Snapshots with flash are easy in Full Auto mode.

indicates the duration. While you can trip the shutter at any time, it is wise to wait until the countdown is completed.

This pre-exposure of the pupils closes the iris in the eye somewhat, reducing the red-eye effect—but to what degree depends on a variety of factors. The intensity of the red-eye effect is affected by the direction in which the portrait subject is looking, the color of the eyes, the flash-to-subject distance, and the focal length of the lens. The usefulness of the red-eye reduction function will vary from person to person and shot to shot. Tall hot-shoe flashes have a larger distance between the flash and optical axis, so the effect will be less than the camera's built-in flash. They also offer the option of bounce flash while maintaining full automatic flash control. Small children with their large eyes are particularly vulnerable and can generally only be free of red eye if photographed using bounce flash.

Caution: Some lens hoods, lenses with a large front element, or long lenses can interfere with the flash illumination and throw a shadow onto part of the image. This is especially true with the EF

17-35mm f/2.8 L USM, 28-70mm f/.2.8 L USM, or EF 300mm f/2.8 L USM. To be on the safe side, don't use a lens hood when shooting with the camera's built-in flash. Shaded areas in the lower half of the film frame usually indicate shadows created by a lens or lens hood.

Using Flash with Camera Exposure Modes

Flash is easiest to use in the green Full Auto mode and in Portrait, Macro, or Night modes. This is true for both the built-in flash and any EOS system flash unit. Hot-shoe flash units can also be used in landscape and sports programs. In low-light or backlit situations, the built-in flash automatically pops up. The red-eye reduction function can be turned on at any time and used in any program mode, but is most suitable in Portrait mode. When the flash icon (lightening bolt) is lit in the viewfinder, the flash unit in use is ready to fire.

Flash photography in green Full Auto mode is recommended for beginners and newcomers to SLR photography who are not highly experienced with flash photography. Photographers who aren't technically inclined can also benefit from fully automatic flash and exposure control.

In the Portrait subject program, flash is often needed and works well when combined with red-eye reduction. Portraits made indoors or in low-light conditions, such as in candlelight, as well as outdoors in the shade or in backlit situations, are great places to use flash. Forget the idea that "flash ruins the mood" and use flash with every portrait you make outdoors. Give it a test: Make two exposures of a person outdoors; one with flash, one without. The portrait made with flash will make the person pop out of the background as well as eliminate any unflattering or distracting shadows on their faces.

Flash is important in the Close-up mode because long lens extensions tend to eat light. With small reproduction ratios and short subject distances, you can use the Elan 7/7E's built-in flash. If the camera's flash is obstructed by longer lenses, a ring light, such as the MR-14EX Macro Ring Lite, can be attached to the front of the lens. The Lite's control unit is mounted on the camera's hot shoe and two individually controlled flash tubes allow the photographer to control depth and modeling in the photograph.

Use Program mode when you want perfectly exposed flash pictures without decisions and calculations.

Note: While you can't use the camera's built-in flash in Landscape or Portrait modes, an accessory flash can, however, be used. Landscape mode is designed for large subject distances and typical subjects are generally outside the range of the built-in flash. The Sports mode selects fast shutter speeds, generally 1/250 or 1/500 second, to freeze movement, but when using flash, the shutter speed is automatically slowed to 1/125 second. This can produce interesting effects with a crisp flash center and a blurred background.

Program Mode

Flash photography is easy in Program mode where perfectly exposed shots are a snap without having to worry about technical details. Flip the built-in flash up or turn on a hot-shoe flash, aim at the subject, and snap the shutter. All you have to do is make sure the flash icon at the lower right of the viewfinder indicates the flash is ready. With any EX-series hot-shoe flash that's set to E-TTL, you should make sure that its ready light is on.

In Program mode, the Elan 7/7E automatically selects a shutter speed between 1/60 and 1/125 second and, depending on the lighting and subject; aperture is also automatically selected. Flash operation and program shift don't mix. As soon as the flash is turned on, any current program shift is cancelled. Manual flash exposure corrections can be entered on the camera and flash exposure bracketing is only possible on the 550EX or MR-14EX. Flash exposure lock is possible when using an EX flash and, depending on lighting conditions, you can select shutter speeds up to 1/4000 second with 550EX and 420EX Speedlites.

Shutter-speed Priority Mode

In Shutter-speed Priority mode, you can use either the built-in flash or accessory flashes such as the Speedlite 420EX or 550EX. Since program shift doesn't work in conjunction with flash, you have no way of matching the shutter speed to subject conditions when in Program mode. This isn't a problem in Shutter-speed Priority mode, since you can select your shutter speed when using flash. You can do this either before or after flipping up the built-in flash or turning on an accessory flash. For best results, EX-series system flashes should be set to E-TTL.

All shutter speeds between 1/125 and 30 seconds are synchronized with flash and can be manually selected. If an exposure time shorter than 1/125 second is selected, it's automatically changed to 1/125 second as soon as the flash is ready or the shutter release is depressed. With Speedlite 420EX or 550EX, high-speed sync is an option. This function, which must be selected on the flash, is indicated by an H next to the flash icon on the LCD panel and in the viewfinder. In this mode, any shutter speed between 1/80 and 1/4000 second can be selected. The aperture is automatically selected based on shutter speed and ambient lighting.

If the smallest or largest aperture is flashing in the display, you should select another shutter speed to avoid incorrect exposure. Manual flash exposure corrections and flash exposure lock (with EX units only) are both available, but flash exposure bracketing is only possible with the Speedlite 550EX or MR-14EX.

When using E-TTL in Shutter-speed Priority mode, flash synchronization with longer exposure times can be interesting. This combination gives you the ability to select a shutter speed to control the appearance of the background, such as a person at dusk in front of an illuminated skyline. A conventional TTL flash control system would illuminate the person correctly while the background would be black. Having a choice of shutter speeds lets you control the background's appearance. If you want to be precise, you can meter the background separately and set the shutter speed to match the flash-based aperture. While it seems obvious, the main subject should be within the flash's range. With slower shutter speeds, you might prefer to use a tripod to keep the background sharp. The short flash duration will ensure that the subject is sharp.

Blurring the Edges

Photographs of subjects in motion where the background is blurred while the main subject has crisp edges surrounded by blurred edges makes an interesting effect. You can create this effect with the Canon Elan 7/7E by choosing a slower shutter speed—1/30 second, 1/15 second, and 1/8 second, depending on the subject's movement—in Shutter-speed Priority mode. The subject should be within the range of the built-in or accessory flash, but you can leave flash exposure control up to the Elan 7/7E's E-TTL flash control system.

Aperture-priority Mode

Both the built-in flash and higher-powered accessory flashes such as the 420EX and 550EX work in Aperture-Priority mode. Having a choice of aperture, you can use depth of field as a creative tool without affecting auto-flash control. You can also control flash range with your choice of aperture. The desired aperture can be selected using the Main Dial, and the camera then automatically selects an appropriate shutter speed between 1/125 and 30 seconds, depending on lighting conditions. Custom Function 9 can be used to automatically select 1/125 second. When using Speed-lite 550EX or 420EX, you can also choose a high-speed sync speed of 1/4000 second. This can be a big help with portraits made under bright light when you want to blur the background using a large aperture but also want to use flash fill. In portraits made with EX system flashes, flash exposure can be stored with the lock button to produce the desired effect. FEL storage can also be used. If you want to freeze movement, high-speed sync can be used for photographing moving subjects.

Manual Exposure Mode

When working in Manual Exposure mode, you can use either the built-in flash or an accessory unit. If you're using an EX-series flash, the Elan 7/7E can work in E-TTL mode, automatically controlling flash exposure based on a test flash, just like in the other programs. But flash photography in Manual Exposure mode requires some experience. In this mode, you can use all of the lens' available apertures and any shutter speed between 1/125 and 30 second. If you select a speed faster than 1/125 second, the Elan 7/7E automatically sets it to 1/125 second, unless high-speed sync is activated on Speedlite 420EX or 550EX. Then, you can pick any shutter speed up to 1/4000 second. Bulb setting for an exposure of any length is always flash synchronized.

Flash photography in Manual Exposure mode, particularly with long exposure times, offers a wide variety of creative opportunities. If you want to capture a natural-looking image, you can do without the convenience of E-TTL and set the accessory flash manually. If you would like to capture the light inside a room as well as the outside in full detail, a conventional TTL system will expose the room correctly while making the outside dark. If you adjust the exposure for the outdoors without using flash, the room

will be dark. If you want to preserve the mood of the scene, the exterior has to be somewhat brighter than the interior. A careful metering of the exterior, a flash metering of the interior using a handheld flash meter and a manually controlled accessory flash are the perfect solution. The flash illumination is controlled with the aperture, the ambient exterior by the shutter speed. With experience and some bracketing, you'll be able to produce acceptable-looking images without a flash meter.

Note: While you can use flash in Depth-of-Field (DEP) mode, it doesn't make sense to do it because the effects of depth-of-field control are overridden in flash photography. When using flash, images will be exposed correctly, but the depth of field will probably not correspond to your DEP intentions.

Highly reflective surfaces, like this gilded statue in front of a white wall, would result in an underexposure without a correction. A manual exposure correction of +1 EV was required.

Exposure Corrections

Any manual exposure corrections made with the camera, including bracketing, affect only the ambient light exposure, not the flash exposure, and shouldn't be confused with flash exposure corrections. With manual exposure corrections, film speed

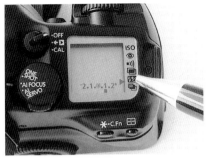

To enter a manual exposure correction on the camera, press the function button until the arrow on the data monitor points at the appropriate symbol on the right side. Enter the desired exposure correction using the front control dial.

information sent to the hot-shoe flash is not affected, so foreground exposure remains the same. The background, however, changes according to the size and direction of the manual exposure correction. Flash exposure corrections, on the other hand, affect the amount of flash on objects within flash range, but don't affect the background.

Even with Canon's advanced E-TTL system, manual flash exposure corrections are occasionally required for subjects containing dominant dark or bright areas. Manual flash exposure corrections can be set on both the Elan 7/7E and EX-series accessory flashes. To enter a correction on the camera, you have to press the function key until the index on the right side of the LCD panel is pointing at the correct icon (flash and a +/–). The desired correction is set using the main dial over a range of plus and minus two stops in half-stop increments. During the process, the correction is displayed on a linear scale and the correction symbol appears in the viewfinder as a reminder. Corrections can be entered on the 550EX by touching the SEL/SET button and entering the desired correction up to plus or minus three stops in half-stop increments. This value will be displayed on the flash's LCD panel.

Second-curtain Sync

When shooting moving subjects with long exposure times, synchronizing flash with the second shutter curtain will produce natural-looking light trails. With second-curtain sync, motion blurs trail behind the subject, not ahead of it, which occurs when normal or first curtain synchronization is used for flash pictures of

moving objects. Synchronization with the second shutter curtain is selected using Custom Function 6. It works for the built-in flash as well as for Speedlites 420EX, 380EX, and 220EX. With the Speedlite 550EX and the MR-14EX, second-curtain sync is selected by simultaneously pressing the plus and minus buttons. The first press sets high-speed synchronization, the second selects second curtain synchronization. Three arrows on the top right of the LCD panel indicate the function is active.

Canon Speedlite EX-Series

The Speedlite 420EX was introduced at the same time as the Elan 7/7E and is optimized for it. At this point, you should be familiar with the methods and advantages of E-TTL as well as other functions such as wireless E-TTL flash control and high-speed synchronization, but the 420EX has even more to offer.

With a powerful guide number of 138 in the 105mm reflector position, its twist and tilt zoom head covers focal lengths from 24mm to 105mm. The zoom positions corresponding to 24, 28, 35, 50, 70 and 105mm are set automatically and the reflector zooms as the lens does. Current focal-length settings are displayed on the back of the flash. Controls for wireless E-TTL operation are located on the unit's foot, and in slave mode the 420EX offers modeling lamp capabilities.

The only unit with more features is the top-of-the-line Speedlite 550EX, which has a guide number of 180 at the 105mm reflector position. The swing and tilt head covers focal lengths from 24mm to 105mm with positions corresponding to 24, 28, 35, 50, 70, and 105mm set automatically. A wide-angle panel increases the angle of coverage to that of a 17mm lens. The illuminated LCD panel on the 550EX provides an overview of all settings, including flash function, reflector position, working aperture, flash range. Two different flash status conditions are indicated: If the pilot light glows yellow-green, the flash is ready to fire, but may not be fully charged. If the pilot lamp glows red, the flash unit is fully charged. If the exposure was correct, a green confidence light between the pilot and the main switch glows for about three seconds after a flash.

Pressing the Elan 7/7E's depth-of-field preview button fires a

The large illuminated data panel on the 550EX clearly displays all settings: flash function, reflector position, working aperture, and flash range in meters.

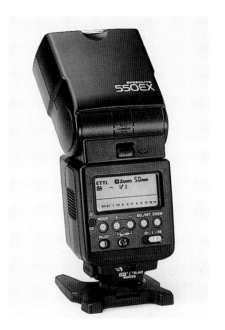

series of flashes with a frequency of 70 Hz so you can evaluate the flash effect for lighting angle and shadows. The Speedlite 550EX offers six custom functions that let you program personal choices such as no modeling light when pressing depth-of-field preview button and the sequence of the exposures in automatic flash bracketing.

Flash exposure bracketing (FEB), which is selected on the flash, allows you to take one exposure on either side of the metered one at up to plus or minus three stops. The increments between brackets are dictated by the camera's correction settings, half-stops in the case of the Elan 7/7E. Other features of the 550EX include flash synchronization on the second shutter curtain, stroboscopic flashing at any desired frequency, and wireless E-TTL flash control.

Flash Exposure Lock (FEL)
When using an EX flash unit, you can lock the flash exposure. The flash exposure can be stored by pressing the exposure lock button (*) on the camera. In the default setting, the camera's

**Press the exposure lock button
to lock the flash exposure.**

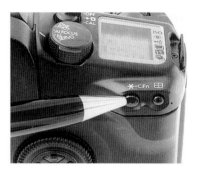

main AF cross-sensor is activated so metering is coupled to it and produces a center-weighted reading. Custom Function 8 allows the metering to be coupled to the manually selected AF sensor or eye-control.

To meter, you must carefully aim the active AF sensor at the subject. Pressing the flash's select button fires a test burst at 1/32 power. For about half a second, "FEL" appears in the viewfinder and LCD panel. At that point, you can frame the image and trip the shutter. The flash exposure will be made according to the stored value. Prior to making the exposure, values stored by FEL can be cancelled by turning the Command Dial to another position. Flash exposure lock must be done before each exposure, meaning continuous exposures are not possible with FEL storage. Turning the Command Dial isn't the only option to cancel a locked-in FEL reading. Pressing either the function or metering mode buttons on the camera's back will work too. Cancellation is indicated when the * next to the flash icon disappears from the viewfinder. FEL cannot be used if the camera is set to Full Auto or any of the basic zone modes, such as Landscape or Portrait.

This is the only TTL flash system in the world that allows the user to take a partial meter reading of the flash illumination, and lock that into memory. The Elan 7/7E takes a partial meter reading of a pre-flash, through the lens, that uses five zones of the 35-zone E-TTL metering system (about 10% of the total picture area). Any flash exposure compensation for light or dark subjects should be dialed in prior to making the FEL reading.

Wireless E-TTL Flash Control

Multiple flash enables the photographer to use sophisticated

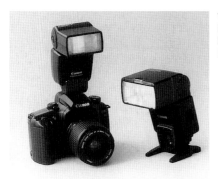

Wireliess E-TTL flash control is available with the Speedlite 420EX (left) and 550EX (right).

lighting to achieve dramatic effects. Canon Speedlite wireless multiple flash technology eliminates the wires that were once used to connect the various flash units, making multiple flash more reliable and easy to set up.

E-TTL flash allows the use of up to three groups of slave units placed in various locations (each group is called A, B, or C). A switch on the 420EX or 550EX's hot shoe lets you select master or slave. The master controlling flash is attached to the camera's hot shoe, while the other slave unit(s) are set elsewhere. Or, instead of using a 420EX or 550EX as the control unit, a Speedlite Transmitter ST-E2 can be mounted on the camera.

To control lighting, power for the flashes in various groups can be controlled manually or automatically. The number of groups is limited to three, but the number of flashes is not. You can control as many Speedlite 420EX's and 550EX's remotely as you wish and even high-speed synchronization can be achieved with wireless E-TTL.

Other Speedlite Flash Units
The best accessory flash units for the Canon Elan 7/7E are the Speedlite 550EX and 420EX. However, long-time Canon users may own older Speedlites designed for other EOS models. These units are mostly compatible with the Elan 7, but there are functional limitations such as the lack of E-TTL control, wireless E-TTL, and high-speed sync. Nevertheless, the features and functions of the Speedlites 540EZ, 430EZ, 420EZ or 300EZ are still useful. They work with A-TTL (Advanced TTL) and measure both ambient and flash illumination—just not as well as the 550EX or

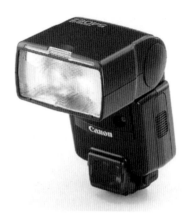

The Speedlite 540EZ possesses a number of features that make it a good choice for use with the Elan 7/7E.

420EX. Flash illumination is not measured by the AF-coupled multi-sensor metering system using a test flash but rather during exposure by a four-zone metering system that measures the light bouncing off the film plane. Once the required illumination is reached, the flash is turned off. A-TTL control also produces a balance between flash and ambient lighting, and a good balance between the flash-illuminated foreground and background can usually be obtained so contrast between foreground and background is minimized.

The Canon Speedlite 540EZ has a maximum guide number of 177 with ISO 100 film and the reflector in the 105mm position. This flash unit has a zoom reflector that can be adjusted to match the angles of view of lenses between 24mm and 105mm. A built-in wide-angle diffusion screen spreads the light to cover an 18mm lens. Other features of this hot-shoe flash include a tilt reflector, stroboscopic function, and AF-assist light.

The Canon Speedlite 430EZ has a zoom reflector covering lenses from 24 to 80mm. The reflector zooms automatically along with the lens if the "A Zoom" function is active. The reflector can be manually positioned and clicks in at 24mm, 28mm, 35mm, 50mm, 70mm and 80mm. The Canon Speedlite 430EZ has a guide number of 138 at ISO 100 at the 80mm reflector position. The zoom reflector can be swung and tilted so bounce flash (with A-TTL) is convenient. In Automatic mode, the flash power can be controlled in third-stop increments by the flash, which is a handy feature when using fill flash. In Manual Exposure mode, the

maximum power can be reduced over six increments. In Shutter-sync mode, the Speedlite 430EZ can be synchronized on the first *or* second shutter curtain. Stroboscopic shots with a maximum frequency of 10 flashes per seconds are also possible.

The Speedlite 420EZ is the predecessor of the 430EZ, with which it shares most of its features. The zoom reflector offers the same positions (24 to 80mm, swing and tilt) as the 430EZ. In wide-angle range, the guide number of the 420EZ is the same as that of the 430EZ, but in telephoto range, the 430EZ produces more power thanks to a better reflector design. Output correction is not available in Automatic mode, and the maximum number of flashes per set of batteries is significantly lower.

Diffusers

Accessory manufacturers, such as LumiQuest, offer a wide variety of diffusers that fit shoe-mount flashes. They come in a variety of shapes and sizes and are generally attached to the head using Velcro. These reflectors and diffusers make the light softer and the shadows less noticeable and are ideal for portraits or still lifes. The best part is that once attached to a flash, E-TTL functionality is maintained.

Accessories

While the Elan 7/7E boasts sophisticated features, accessories will enhance your enjoyment of the system and extend the camera's usefulness to include new photographic applications. The BP-300 Battery Pack will add greatly to your photographic enjoyment. Accessories such as filters can be used for technical or creative purposes.

The BP-300 Battery Pack

The BP-300 equipped with four AA batteries.

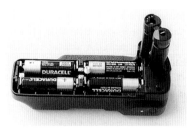

The switch for CR 123A batteries.

The BP-300 equipped with two CR 123A lithium batteries.

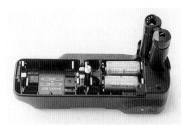

The BP-300, specially designed for the Canon Elan 7/7E, is considered by many to be a must-have accessory. It can be loaded with either two CR 123A lithium cells or, by flipping up the spacer mechanism, with four AA batteries. The AAs can be alkaline, NiCd, or NiMH batteries, but not lithium. Four AA lithium batteries produce too much voltage and could possibly damage the camera's internal electronics. Because battery access to the BP-300 is through the top of the grip—the part covered by the camera's base—you should install batteries *before* attaching the grip to the camera.

Using AA alkaline batteries at 68°F (20°C), the Elan 7E can shoot up to about 70 rolls of 36-exposure film with Eye Control. If the built-in flash is used for half of the shots, this drops to about 20 rolls of 36-exposure film.

Filters

Most people think of filters as something to use to protect the front element of the lens. Nothing could be further from the truth. Filters are tools, accessories that can be used to improve a photograph—to enhance reality, communicate a mood, or to portray a scene as closely as possible to how the eye perceives it. Filters enable you to better communicate reality or expand your creativity.

Filters are loosely divided into four categories: those for general photography, for black-and-white film, for use in color photography, and filters for special-effects.

Filters for General Photography
UV and Skylight Filters: UV and Skylight (1A) filters are used primarily to protect the front element of a lens from scratches —or worse! Having one of these filters attached to your lens also prevents costly damage to the filter ring at the front of the lens housing.

A UV (ultraviolet) filter, which appears clear, simply absorbs ultraviolet radiation. Because color film is more sensitive to UV rays than our eyes, photos may appear to have a cold cast because of the excess radiation. With black-and-white film, UV light appears as excessive haze. A UV filter is helpful for shooting landscapes,

Filters not only protect your lenses, but also enhance your photographs. The Tiffin® UV Protector filter (right) cuts haze and atmospheric pollution. The 812 (below) will remove "cold" colors. The conversion filter 80A (below right) eliminates the yellowish cast when shooting indoors with daylight-balanced color film.
Photographs by John Drew.

snow scenes, or on overcast days. A good UV filter, such as a Tiffen Haze 2A, is essential for high-altitude photography.

The skylight filter is used with color slide films to reduce the blue cast that may occur in shady scenes or on overcast days. It also removes some of the excess blue associated with photography at long distances or at high elevations, but a pale amber 81A or pink-amber 812 filter is more effective in "warming" such scenes. A skylight filter is less important with color negative films because the photofinisher can adjust the color balance during printing. Skylight filters are almost clear so there is no loss of light. This filter is often used to protect the front element of a lens from fingerprints, sand, ocean spray, and scratches.

Polarizing Filters: Polarizing filters may be used to darken blue skies, remove reflections from glass and water, and to increase color saturation by wiping glare from reflective surfaces. The glass

in polarizers is mounted in a ring that allows the filter to rotate freely. You can view the changing effect in the viewfinder as you rotate the polarizer. Reflections in the scene may become subdued or disappear; when the effect is just right, take the picture.

Even when there are no noticeable reflections, minute specular reflections in a scene may affect color saturation. Removing such glare increases color saturation, or intensity, in the picture. Again, the effect is visible through the finder. Similarly, a polarizer is useful for intensifying the blue of a clear blue sky in areas at 90° to the sun.

The gray glass of a polarizer typically absorbs enough light to require an exposure increase of approximately 1-1/2 stops. Since the Elan 7 and 7E meter through the lens, they automatically compensate for the loss of light caused by a filter.

Autofocus cameras such as the Elan 7 and 7E require a "circular" polarizing filter rather than a "linear" polarizer that can interfere with metering and focusing operation. Both types look the same and produce the same effects.

During focusing, the front element or filter mount of many autofocus lenses rotates. This changes the effect of the polarizing filter. The best solution is to focus first and then rotate the filter to the desired position to achieve the intended effect.

Neutral-density Filters: Neutral-density (ND) filters are an overall dark neutral gray color. Their purpose is strictly to reduce the amount of light striking the film. They can be used with black-and-white or color films.

The **ND2X** absorbs one stop of light and the **ND4X** absorbs two stops of light. When these filters are attached, your camera's TTL meter reads the reduced amount of light and provides the correct metering information. Neutral-density filters are helpful in situations where you want to increase shutter speed or lens aperture beyond what would normally be allowed by the film in use.

Filters for Black-and-white Photography

Black-and-white photography is dependant on tones and shades of white, gray, and black to define the subject. By using certain filters, the gray tones can be manipulated to render the subject more effectively.

Most black-and-white photographs can be analyzed using a

If the foreground subject is properly exposed, the bright cloudless sky may be overexposed. Adding a polarizing filter absorbs polarized light to add tonal value to the sky. Photograph by Joe Farace.

gray scale with white at one end, black at the other, and various shades of gray in the middle. Filters allow you to adjust how the various colors in nature are rendered in relation to the gray scale. A good rule to remember is that subjects that are the same color as the filter become lighter, and subjects that are the color complement of the filter become darker.

A yellow filter renders blue (the sky, for instance) as darker gray than it would be in a photo made without a filter. Shooting landscapes with a yellow filter makes the sky a pleasing, realistic gray tone and the clouds become more apparent.

A red filter is used to create a very dramatic appearance by producing a brilliant contrast in most images. This means that it creates great extremes between the darkest and lightest tones, with fewer shades of gray to soften the image. Because green is the complement of red, green foliage is rendered very dark when shot with a red filter, while the red accents (flowers or apples, for

Tiffen® Yellow 15 filter, used for black-and-white photography, enhances landscapes by darkening blue tones, creating dramatic effects. Photograph by Roger J. Waindle.

example (become lighter in tone. Also, a blue sky becomes dramatically foreboding when shot with a red filter, appearing almost black under most conditions.

An orange filter is a happy medium between the yellow and red filters. Whereas the yellow filter produces a mellow image and the red creates a stronger effect, the orange takes the middle ground in tonality and contrast. It's a good starting filter for the new black-and-white photographer, but sooner or later you'll want to have the red and yellow as well.

The fourth, the green filter, allows subjects that are green or yellow to be rendered light in color. This is also an excellent filter for doing black-and-white portraits because it darkens lips and adds subtle contrast, giving people a healthy appearance. It is also a good filter for forest shots because it darkens the tree trunks and gives foliage a lighter, softer look.

Filters for Color Photography

Filters designed for color film generally change the color in some fashion. Some filters "clean up" colors, some enhance them, while others alter them for creative effect.

Filters and Color Temperature: Most color film is balanced for daylight. Daylight film is formulated to best render color when it is exposed to light that approximates 5500° Kelvin—bright sunlight or flash, not cold fluorescent lights or incandescent household lights.

Conversion Filters: Conversion filters are essential to get proper color under artificial or studio lighting. The 80A, 80B, and FLD are the most common choices for specific lighting situations in which the light must be altered in order to achieve proper color balance. They are typically used with daylight film.

The **80A** is a dark blue filter. It renders correct color when shooting daylight-balanced film under 3200° Kelvin (K) tungsten lights. The color temperature of your basic house-lamp light bulb is about 3200° K. If you shoot daylight film using only lamplight, the photo will come out with a funny, yellowish-orange cast. Using an 80A filter in front of the lens corrects that effect, making the image's color appear more natural. The **80B** is a medium blue filter. It converts daylight film for correct color balance with

Special effects can be achieved with the use of filters. Here a "halo" effect is achieved using the Pro-Mist® 2 filter to soften the image and make the highlights glow. Photograph by Christie Spencer.

common photofloods, which are 3400° K. You can also buy tungsten-balanced (Type A) film for this application, but this filter accomplishes correct color balance when shooting daylight film under 3400° K bulbs.

The color of an **FLD** filter is magenta. This filter takes the "green" out of pictures photographed with daylight film under fluorescent lights. Perfect correction is not possible with fluorescent lights because the color cast varies greatly by bulb type and age. The FLD will get you close and eliminate most of the sickening green glow.

Filters for Special Effects

These kinds of filters are creative tools. They allow you to make stars from points of light, add diffusion to a portrait, or make a sky lavender or tobacco in color. Your Canon dealer offers many filters to choose from—the only limit is your imagination.

The **Close-up** filters are not really special effect, but special-purpose filters that enable you to take close-up photos of flowers, coins, etc. They come in a set, +1, +2, and +4, each filter a little stronger in its magnification. They can be used individually or in combination with one another to produce varying degrees of magnification and can be used on any focal length lens or zoom. (However, if you are stacking the filters, check for vignetting with wide-angle focal lengths.) Each lens' magnification varies with the close-up filter(s) attached as far as working distance and ultimate magnification. The following chart should help get you started in knowing what you need to achieve the magnification you desire with your particular lens.

Lens Hoods

Canon offers lens hoods for EF lenses. They are available as accessories and are designated EW (wide-angle), ES (Standard), or ET (telephoto) with a two-digit number and sometimes with additional letters or Roman numerals. Use the instructions shipped with each lens or lens tables from Canon literature to determine which hood is correct for your lens. Lens hoods play an important role in protecting against mechanical damage, flare from stray light, and reflections.

Custom Functions

To change a Custom Function, move the Command Dial to the position marked C.Fn. Then enter the desired setting by pressing the Function setting button.

The Canon Elan 7/7E offers 13 Custom Functions with 34 different settings, allowing you to reprogram certain camera functions to match your style of photography. Access to Custom Function programming is by turning the command dial to the position marked C.Fn. When you do, the most recently modified Custom Function appears on the LCD panel. The letter C along with the numbers identifying the Custom Function and the sub-option are displayed in the top row. "C.Fn" appears in a black box directly underneath these numbers. You can select the desired Custom Function by turning the main dial and pressing the double-function C.Fn button (*) to enter the required setting. The setting is confirmed by turning the program dial to another position. When a Custom Function is modified, "C.Fn" appears on the LCD panel. To turn a Custom Function off, select zero in the

corresponding Custom Function. The following table displays an overview of the various Custom Functions settings:

Custom Function 1: Film rewind speed
➢ 0—Low speed, quiet mode
➢ 1—High speed
The default setting (CF-1, setting 0) for the film rewind speed is extraordinarily quiet. If speed is more important than silence, CF-1, setting 1 programs the camera to rewind the film quickly, accompanied by a slight increase in noise.

Custom Function 2: Film leader position after rewind
➢ 0—Inside cartridge
➢ 1—Leader out
When the film is rewound, the film leader is normally pulled all the way back into the cartridge (CF-2, setting 0). This prevents you from loading an exposed roll of film and producing double exposures. If you want to reload a partially exposed roll, CF-2, setting 1 programs the camera to leave a little of the leader visible.

Custom Function 3: DX-coded film speed setting
➢ 0—Enabled
➢ 1—Disabled
Virtually all films are supplied with DX coding. These checkerboard patterns enable the film cartridge to communicate the film speed and number of exposures to the camera. The default setting for CF-3 sets the film speed automatically when a roll of film is loaded. If CF-3, setting 1 is used, the photographer must set the film speed manually. The previous setting is maintained even when a new roll of film is loaded.

Custom Function 4: Shutter Release/* button functions
➢ 0—Pressing the shutter release halfway activates AF. Pressing the * button activates AE Lock.
➢ 1— Pressing the shutter release halfway activates AE Lock. Pressing the * button activates AF.
➢ 2—AF start with shutter presses halfway/AF stopped with *
With CF-4 in the default setting, partially depressing the shutter release activates autofocus. Pressing the * button activates

AE Lock to retain the exposure settings. CF-4, setting 1 switches the buttons' functions. Now the * button activates AF and the shutter release locks exposure. With CF-4, setting 2, partially depressing the shutter release activates autofocus and pressing the * button stops autofocus operation.

Custom Function 5: Mirror lock-up
➢ 0—Disabled
➢ 1—Enabled
If you set CF-5, setting 1, pressing the shutter release causes the reflex mirror to lock up. You then press the shutter release a second time to take the picture. The mirror goes back down after 30 seconds if you don't take a picture.
This setting is used to prevent vibration due to mirror movement and can improve sharpness, especially with macro photography, copy work, or with long lenses.

Custom Function 6: Shutter curtain synchronization with flash
➢ 0—First-curtain sync
➢ 1—Second-curtain sync
With CF-6 setting 1, the flash fires at the end, rather than at the beginning of an exposure.

Custom Function 7: AF-Assist Light/ Flash Illumination
➢ 0—Built-in or accessory flash emits AF-assist light and main flash fires
➢ 1—Built-in or accessory flash emits no AF-assist light but main flash fires
➢ 2—Using the built-in flash: no AF-assist light but main flash fires Accessory flash: emits AF-assist light and main flash fires
➢ 3—Built-in or accessory flash emits AF-assist but main flash does not fire

Custom Function 8: Partial metering locks with focusing point/FEL
➢ 0—Disabled
➢ 1—Enabled
Partial metering and FE Lock are normally linked to the central AF point. With CF-8, setting 1, both can be linked to the active AF point.

Custom Function 9: Flash sync speed in Av mode
➢ 0—Set automatically
➢ 1—Set to 1/125
With Aperture-Priority (Av) mode, the flash sync speed is normally varied according to the ambient light level. Slow sync speeds can produce streaks or ghost images, which may be undesirable. To avoid this, use CF-9, setting 1 to maintain a sync speed of 1/125 second.

Custom Function 10: In-focus focusing point blinks
➢ 0—Enabled
➢ 1—Disabled
The active AF point blinks the instant that focus is achieved. If you find this distracting, disable the function using CF-10, setting 1.

Custom Function 11: Focusing point selection method
➢ 0—Focusing point selector button plus Quick Control Dial
➢ 1—Quick Control Dial only. (Auto selection with focusing point selector button (only))
➢ 2—Focusing point selector plus Main Dial or Quick Control Dial
This Custom Function varies control or combination of controls used to select a focusing point.

Custom Function 12: Switch to center focusing point with focusing point selector
➢ 0—Disabled
➢ 1—Enabled
With this Custom Function enabled, pressing the focusing point selector activates the center focusing point.

Custom Function 13: Lens AF stop button
➢ 0—AF Stop
➢ 1—AF Start
➢ 2—AE lock during metering
➢ 3—Switch between automatic and manual focusing point selection
➢ 4—AF mode switch between One-Shot AF and AI Servo
➢ 5—Start Image Stabilizer

176